# The Sumi-e Dream Book

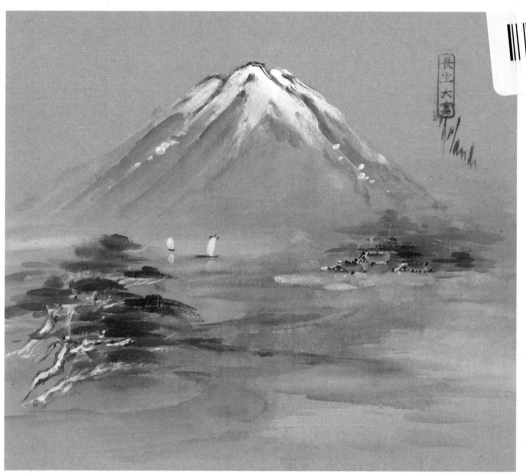

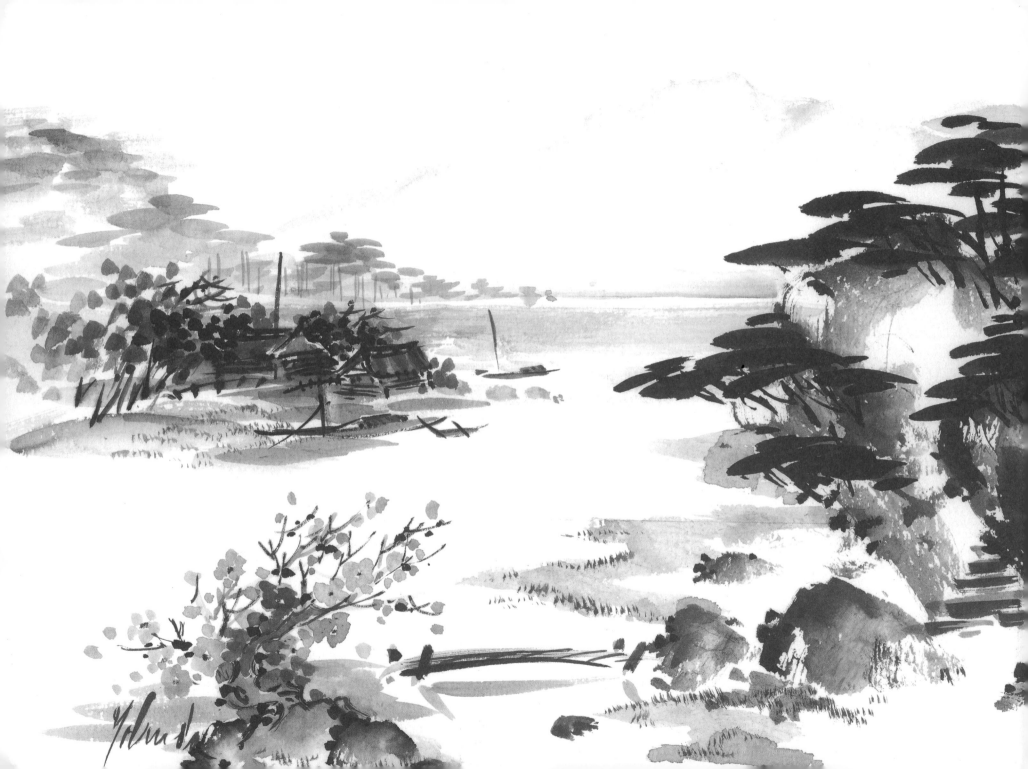

# The Sumi-e Dream Book

## An Impressionist Approach to the Art of Japanese Brush Painting

### Yolanda Mayhall

**with Ted Mayhall**

WATSON-GUPTILL PUBLICATIONS
NEW YORK

Senior Acquisitions Editor: Candace Raney
Senior Editor: Alison Hagge
Production Manager: Hector Campbell
Cover design: Sivan Earnest
Interior design: Areta Buk/Thumb Print

First published in 2003 by Watson-Guptill Publications
a division of VNU Business Media, Inc.
770 Broadway, New York, NY 10003
www.watsonguptill.com

**Library of Congress Cataloging-in-Publication Data**

Mayhall, Yolanda.
    The sumi-e dream book : an impressionist approach to the art
of Japanese brush painting / by Yolanda Mayhall with Ted Mayhall.
        p.   cm.
    Includes index.
    ISBN 0-8230-5023-8
    1. Sumie—Technique.  2. Ink painting, Japanese—Technique.
    3. Ink painting—Technique.  I. Title: Impressionist approach to the
    art of Japanese brush painting.  II. Mayhall, Ted.  III. Title.

    ND2462 .M462 2003
    751.4'252—dc21

                                                    2002011145

The principal typeface used in the composition of this book was 10.5-point Berkeley Book.

Unless otherwise specified, all art in this book was created by Yolanda Mayhall.

HALF-TITLE PAGE:
*Mt. Fuji and Pines*
From the collection of Wendy J. Mayhall.

TITLE PAGE:
*Beginning of My Dream Journey*
From the collection of the artist.

Manufactured in China
First printing, 2003

1  2  3  4  5  6  7  8  9 / 11  10  09  08  07  06  05  04  03

We would like to acknowledge the following organizations for their gracious assistance: Charles E. Tuttle Publishing Co. for permission to reprint short phrases from *Japanese Ink Painting* by Ryukyu Saito; Princeton University Press for permission to reprint short phrases from *The Mustard Seed Garden Manual of Painting* by Mai-mai Sze; Random House, Inc. for permission to reprint excerpts from *The Floating World* by James A. Michener; and San Francisco State University, The Metropolitan Museum of Art, and the Museum of Fine Arts, Boston for permission to reprint images in their collections.

We would also like to thank Yasutomo and Co. for their assistance and guidance for the Japanese art materials.

And finally we would like to extend our gratitude to the staff of Watson-Guptill Publications—Candace Raney, Alison Hagge, Hector Campbell, Sivan Earnest, and Areta Buk—for their expert guidance and patience.

We would like to dedicate this book
to our daughters,
Wendy J. Mayhall and
Barbara Hunter,
and to our friends, students,
and patrons,
each of whom contributed
in some special way
to making this book possible.

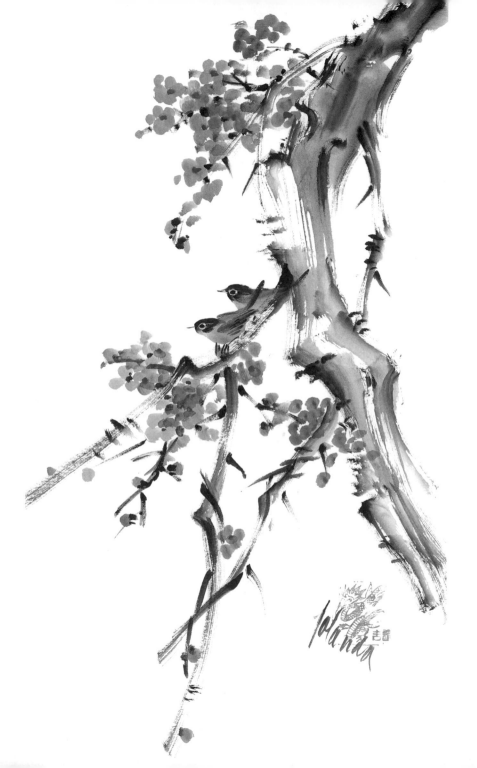

THE HARBINGERS
OF SPRING

*From the collection of
Wendy J. Mayhall*

# Contents

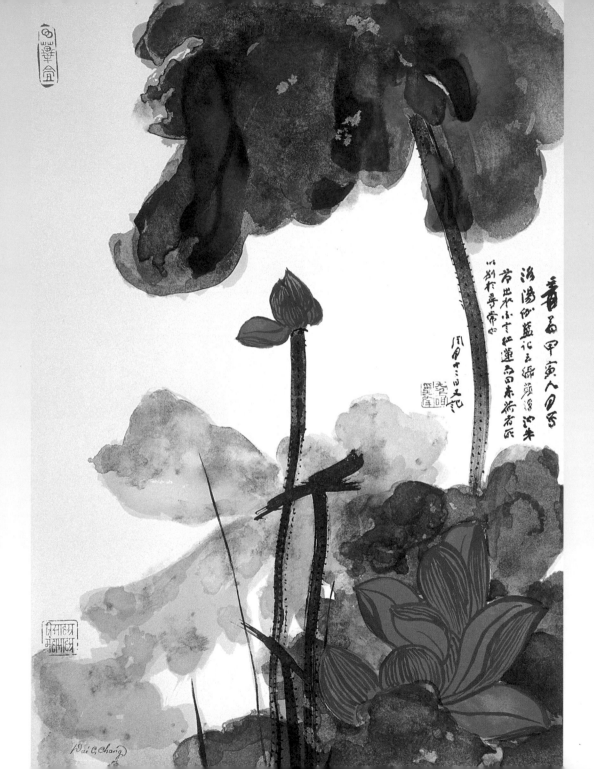

*Chang Dai-chien,*
CINNABAR LOTUS,
*1974–1975.*

*Lithograph. 29 × 20 1/2*
*inches. Collection of San*
*Francisco State University,*
*Gift of Wil and Marilyn*
*Fountain.*

# An Introduction to Sumi-e Dream Painting

As a child, I lived with my family in an apartment in the Bronx and spent many hours fascinated by my mother's silk Japanese lampshade—with its long, silk fringe and beautifully rendered brush strokes of distant mountains holding tiny villages tucked in here and there. All around the bottom of the shade, just above the fringe, were paths meandering around mists of flowers through which S-shaped ladies, with their jet-black hair piled high, strolled to magical destinations. The ladies were gems themselves, for their kimonos and parasols were decorated with delicate brush paintings of birds and flowers in incredible color combinations.

I would dream of walking with these lovely ladies over the curved bridges and into the open teahouses or climbing up the steep mountain passes to mysterious pagodas perched on mountaintops, high in the clouds. I would then try to draw my own dreamscapes in my blanket-draped hideaway on my fire escape, high on the sixth floor.

How could I know that someday I would live in Japan and study the brush-stroke language sumi-e and make my dreamscapes come to life?

This is a little song I learned in the first grade. It has stayed with me all these years and sometimes I think it has guided my artistic goals.

RIDING RIDING LET US GO WHERE THE CHERRY BLOSSOMS GROW;

PRETTY PARASOL AND FAN, IN FAR OFF JAPAN!

For me, practicing and teaching sumi-e has been a lifelong passion—a lifelong career. I was first formally introduced to this ancient art of ink painting in Japan in 1955 and it mysteriously seems to grow more relevant, more perfect with time. This is apparent from some of the work of the age-old dream journey painters such as Zong Bing to the modern-day dream traveler Seiho Takeuchi.

Information about this art's journey through time is vast and museum personnel have graciously accommodated me in my quest to learn. More and more, museums, galleries, and private collectors have been exhibiting their treasures and sharing their knowledge with the public. My husband, Ted Mayhall, a professional artist and calligrapher, and I began this journey forty-seven years ago. Now we work together—interpreting, encouraging, and guiding each other. The study of this technique remains a demanding and complex art that seems to grow more involved and exciting.

In *The Sumi-e Book,* my first book published by Watson-Guptill, I presented this classic art as clearly and simply as possible so artists of all ages would understand and use its basic language. With *The Sumi-e Dream Book* my goal is to allow artists to move naturally into the impressionistic world of dream painting—a world that involves fantastic landscapes as well as a dazzling array of colors. If I can accomplish this, I will be content.

"WE ARE THE DREAMERS OF DREAMS."

—ARTHUR O'SHAUGHNESSY

# A Brief History of Sumi-e

Centuries ago, in the sixth century, Japanese scholars journeyed to China to study Chinese culture and brought back to their homeland examples of a number of Chinese arts—including calligraphy and monochrome ink painting. Once in Japan, the practice of monochrome ink painting was adopted both by Zen Buddhist priests as well as by scholar-artists of the literati and it became known as "sumi-e" (which literally means "ink picture"). The priests valued the way sumi-e searches for the expression of line, mass, and depth through monochromatic tones and they used it in their teaching programs as a Zen exercise. The scholar-artists indulged in unifying sumi-e, haiku (poetry), and *shodo* (calligraphy) within a single artistic expression, sometimes collaborating with friends to create a single scroll. At first the priests and the scholar-artists imitated the Chinese style, but soon they developed a unique Japanese style. This brush-painting technique slowly spread in popularity, eventually flourishing during the Kamakura period (1185–1333 C.E.) and strongly influencing Japanese art.

Tracing the history of sumi-e, one discovers five major schools of technique and expressions—from the ancient linear school to the more recent complex expressionistic school. Though distinct, these schools intermingled with and enriched each other throughout the Kamakura period.

Briefly, the Yamato-e School promoted a linear style, which was characterized by a high-quality thick-thin line technique. The Kanga School emerged about the time when Zen Buddhism was introduced to Japan from China. The Buddhist priests embraced sumi-e for their artistic expression and added their style of austerity and spiritually. They favored pure sumi-e and their art was individualistic and dynamic with economy of stroke. Sesshu Toyo, a Zen Buddhist priest, contributed his talent to the Kanga School with his famous *Long Scroll,* depicting a Zen landscape. The styles of these two schools blended with each other, inspiring the Rimpa School, with its rich, decorative appearance that stimulated new ideas and media. The Nanga School benefited from all three of these visual directions and was embraced by the scholar-artists of the literati, who found its form to be a perfect vehicle for their poetry, philosophy, free spirituality, and individual expression. They enjoyed the soft dynamic lines of the traditional "Four Gentlemen"—Bamboo, Wild Orchid, Chrysanthemum, and Plum Branch—which inspired their poetry and *shodo.* The fifth school, the Suiboku School, is defined by strokes that are painted with lively and dynamic action—including *haboku* and *hatsuboku* strokes. *Haboku* strokes are fairly dry and create an exciting effect called "flying

whites." *Hatsuboku* strokes are wetter, living up to the literal translation of *"hatsuboku,"* which means "ink splashing forth." Both of these strokes helped form the building blocks for modern sumi-e styles.

Eventually all of these aesthetic achievements led to a new departure in Japanese art—the famous *ukiyo-e* (which translates as "pictures of the floating world") woodblock prints of the seventeenth, eighteenth, and nineteenth centuries. These prints made their way to the European continent and made a powerful presentation at the Paris Exposition Universelle in 1867. There, they influenced an important group of young, developing artists—the Impressionists. The art of Édouard Manet, Mary Cassatt, and Edgar Degas all show the influence of Japanese art in various ways.

As is often the case, artistic influence is a two-way street. Contemporary Japanese ink painting exhibits technical influences from Western artists, especially the Impressionists and Expressionists, though the extent of this influence differs according to the individual artists. One of the more notable enhancements is the addition of color to this traditionally black-and-white art. Despite the changes and developments that have occurred over the years, to my way of thinking the intrinsic character of sumi-e has never wavered, surviving these many centuries. And thus sumi-e is currently enjoying a new popularity as a spiritual, yet simple and effective, way of painting.

*Yolanda,* BIRDS AND BAMBOO, *1995.*
*From the collection of Ken and Stella Yarbor.*

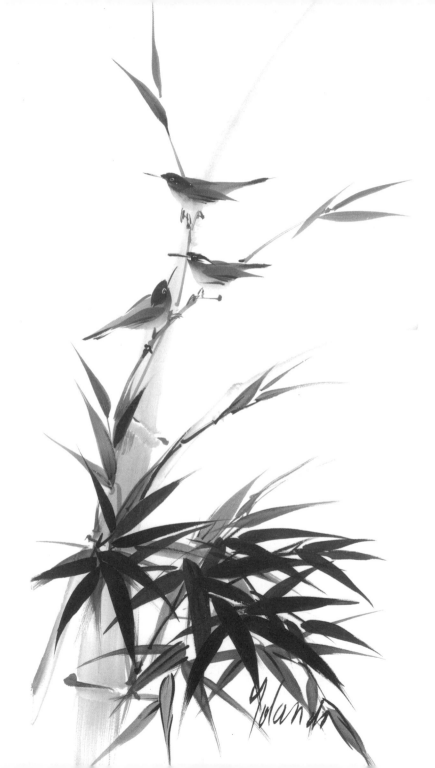

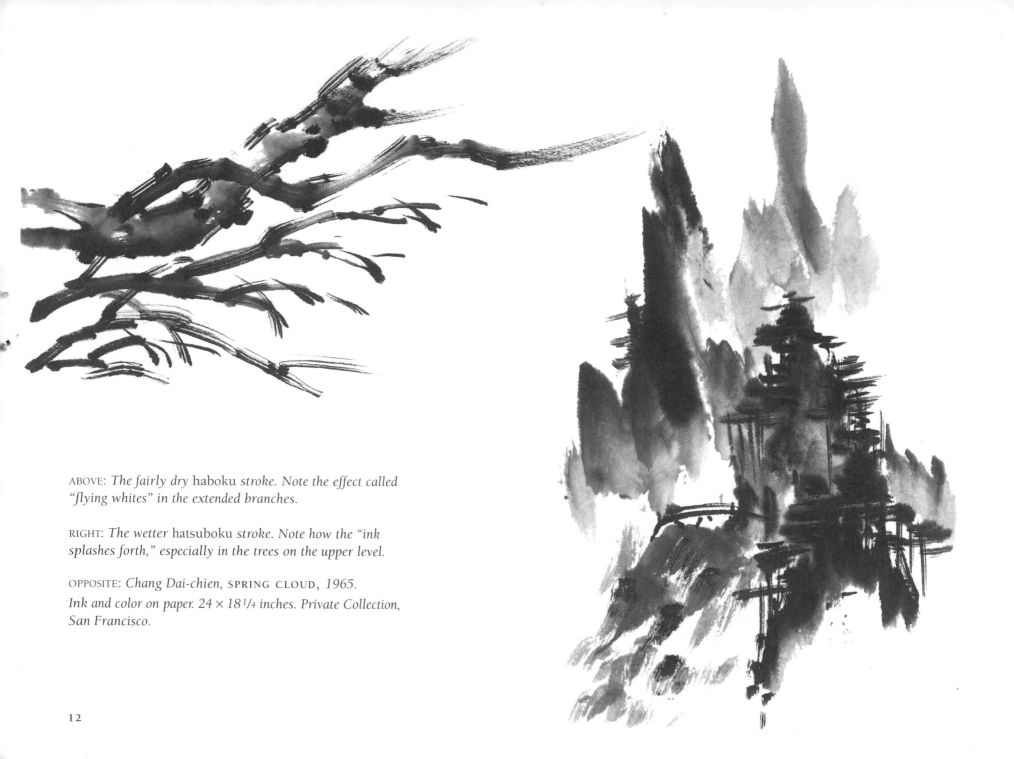

ABOVE: *The fairly dry* haboku *stroke. Note the effect called "flying whites" in the extended branches.*

RIGHT: *The wetter* hatsuboku *stroke. Note how the "ink splashes forth," especially in the trees on the upper level.*

OPPOSITE: *Chang Dai-chien,* SPRING CLOUD, *1965. Ink and color on paper. 24 × 18¼ inches. Private Collection, San Francisco.*

# Studying the Dream Journey Painters of China and Japan

Although sumi-e and dream journey painting are related, they differ in an important way. The classic sumi-e painter presents a visual treasure; the dream journey painter tells a story. Both forms enjoy the freedom inherent in brush painting.

It is said that stories about the dream journey painters are recorded in the archives of dynastic China as far back as the fourth century. These painters tended to be intellectuals who enjoyed spending their time making beautiful calligraphy, writing poetry, and painting. However, these "unfortunate times," as they were called, were plagued with political upheavals and, as a result, these artists became reclusive, for it was safer to stay in their homes and paint.

Their mastery of the structured system of brush painting and brush writing enabled them to paint/write their memories and dreams. They would pull compositions apart and reassemble them at will into imaginary dream landscapes. Likewise, they could content their travel urges by painting their fantasies on the walls of their dwellings. An artist's escape into the land of spiritual painting wrapped him and his audience of art lovers in contemplation, allowing them to wander among the vast scenery of hills and valleys of an imaginary Shangri-la, without ever leaving home. Because these painters were such an exclusive group of intellectuals, they were able to teach and pass their skills and ideas on to each other, firmly establishing the schools of the dream journey painters. To this day, the work of the dream journey painters has been preserved in museums, art institutions, and private collections.

While visiting one of these galleries many years ago, I discovered a book about Katsushika Hokusai that featured examples of both his fine art and his commercial wood-block prints. I admired the wide range of his skills and his determination to pursue the glory of art for his entire life. I especially enjoyed his dream journey works of Mt. Fuji, for they became my dreams as well. His work seemed contemporary and I felt I could relate to him. This is why I called upon Hokusai to be my personal guide and mentor. Hokusai's lead will help me dream-paint into the realms of my imaginative worlds. Hokusai and sumi-e will help me create my personal memorial.

The artists listed on the following pages represent a tiny sampling of the masters of ink painting. Research these artists and discover new ones. I hope you will find one whose dream journeys entice and inspire you.

# Sesshu Toyo (1420–1506)

Throughout history many sumi-e ka (ink picture painters) have also been dream journey painters, but one of considerable note was Sesshu Toyo, a Japanese painter. Though he was a Buddhist monk for his whole life, Sesshu was devoted to painting. The six-panel folding screen called *Birds in Trees,* which is one of a pair, is a fine example of his ink-on-paper work.

In 1467 Sesshu journeyed to China, staying for almost a year—absorbing the landscape, visiting Zen monasteries, and studying Chinese paintings. However, it wasn't until eighteen years later that Sesshu searched back into his memory and painted his impressions of those travels. The result was the famous *Sesshu's Long Scroll,* a 51-foot-long and 1-1/4-foot-high Zen dream journey that is said to have been painted in a single peaceful day. The scroll, which is in the collection of the National Museum in Tokyo, Japan, is a national treasure. However, it can also be seen in its entirety in the folding book called *Sesshu's Long Scroll.*

Sesshu painted this classic work with traditional monochromatic brushwork and faint color washes. It depicts his travels while moving through the four seasons. Each season is described in the style of the brush stroke. Strong, angular strokes suggest winter. Sprightly strokes suggest budding spring life. Summer is shown with moist-looking strokes that evoke verdant growth. Autumn's brush strokes are crisp and the anatomy of the trees and bushes are dominant.

When one experiences this scroll, the seasons and landscape change as it is gradually unrolled, giving the viewer a feeling of the passing of time and of traveling with the artist. It is a true dream journey!

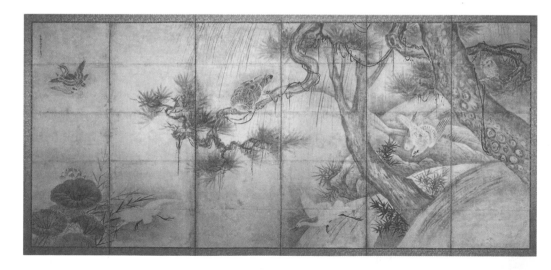

*Sesshu Toyo, formerly attributed to,* BIRDS IN TREES, *date unknown.*

*One of a pair of six-panel folding screens; ink on paper. 63¼ × 139¹/₁₆ inches. Museum of Fine Arts, Boston, Fenollosa-Weld Collection, 1911; 11.4140.*

# Cheng Zhengkui (1604–1676)

Cheng Zhengkui, who was born in the Beijing area of China in 1604, was prominent among the dream journey painters of his time. When he reached maturity, he was accepted into the circle of elite scholars and spent his political career as a high government official to the Manchu Court. In that period of his life he also entered the realm of a scholar painter and buried himself in his art by producing the first of his dream journey series.

Cheng was a prolific painter and it is said that he painted at least five hundred scrolls, many of which were horizontal and unrolled to dramatic lengths. For example, Cheng's *The Imaginary Journey among Streams and Mountains* scroll in the Los Angeles County Museum of Art is 14 1/8 × 210 1/4 inches. Painting on hand scrolls has many benefits. They can be rolled up and stored. They can be transported conveniently. They also free the artist to express him- or herself, as they don't confine the creator to a defined space, as do wall murals, for instance. Cheng's dream journey scrolls depicted journeys to imaginary places, which seem to support the theory that he was escaping the world of political strife and was content to paint in his studio.

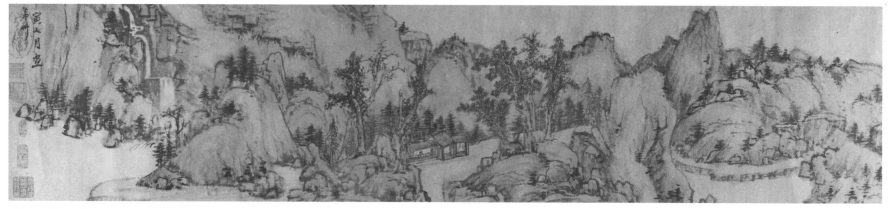

Cheng Zhengkui, DREAM LANDSCAPE, *1674.*
*Handscroll: ink and color on silk. 9 1/8 × 42 1/3 inches. The Metropolitan Museum of Art, Gift of Harry Lenart, 1955.*

# Seiho Takeuchi (1864–1942)

Unlike many dream journey painters of the early years, sumi-e painter Seiho Takeuchi was very mobile. In 1900 and 1901, the Japanese government and the city of Kyoto sent him to Europe as an observer to the International Exposition in Paris. After visiting major European countries as well as China, Takeuchi returned to Japan with photographs, sketches, books, paints, Western techniques, and most important, his memories.

Although his training was rooted in traditional Japanese art, he was intrigued by Western art techniques and developed his own unique style, which can be characterized as having a transcendental sensitivity, still realistic and powerful, that incorporates a Western artistic sense into traditional Japanese painting. Among the paintings he created during visits to Europe and China is the masterful *Scenes of Chiang-nan,* where Takeuchi captured the daily life in an ancient Chinese village. The villagers' work, their emotions, their food, even the smells of the village are most palpable. Yet there is that familiar dreamlike quality that makes one feel as if Takeuchi knew this village—as if he has been there, if only in a dream.

I am most fond of his animal paintings, such as *Puppy at Rest*. I was fortunate to have studied with a Takeuchi disciple in Japan who had mastered the philosophy and painting techniques promoted in the Takeuchi style.

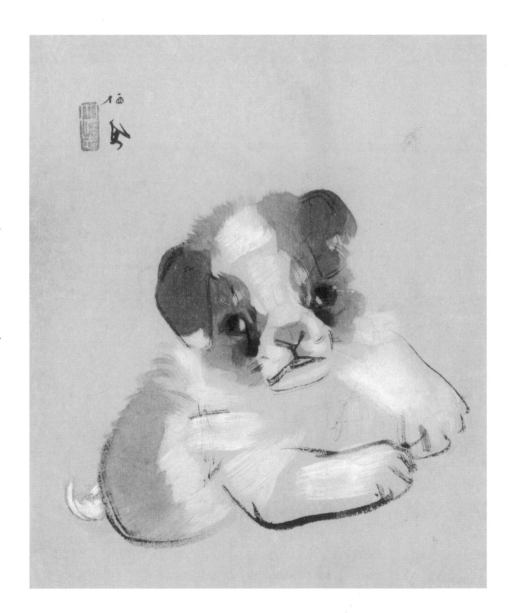

RIGHT: *Seiho Takeuchi,* PUPPY AT REST, *circa 1920.*
*Sumi ink and color on a shikishi board. 10³/4 × 9¹/2 inches.*
*From the collection of Yolanda Mayhall.*

# Katsushika Hokusai (1760–1849)

Among many other things, Japanese-born Katsushika Hokusai was a bookseller, novelist, poet, and an itinerant painter of banners. As an artist, it is said that he produced about forty thousand separate drawings. Some of the most famous were the woodblock prints featured in the two series *One Hundred Views of Fuji* and *Thirty-six Views of Fuji.* (The latter included perhaps his single-most famous print, *The Great Wave at Kanagawa.*) Hokusai's work ranged from traditional paintings of ladies in kimonos to sumi-e sketches of everyday working people.

Hokusai married twice and fathered several children, notably his daughter Oei, a gifted artist, who looked after her father—though Hokusai was highly a resourceful man with a finely hewn survival instinct. During the course of his life, he had more than fifty aliases and lived in ninety-three houses. Hokusai survived a bad stroke at sixty-eight by ministering to himself with Chinese herbs. When he was seventy-six he survived a famine by inviting people with extra rice to make splashes on paper, which he linked together, producing spirited paintings. At the age of seventy-eight, his eighty-seventh dwelling burned to the ground, destroying everything, including his notes and sketches, but he remained undismayed and began new projects until his death at nearly ninety years of age.

Well-known for his woodblock art, Hokusai liked to be described as a painter, but he was not limited to painting from reality. It has been noted that the scenes depicted in many of the prints of *One Hundred Views of Fuji* seemed to combine observed images with sketches from trips of long before. Hokusai began his work for the *Thirty-six Views* and *One Hundred Views of Fuji* when he was seventy-three years old, probably in his tiny studio in Edo.

In my opinion, Hokusai was the consummate dream journey painter. In studying his work, I found him to be the most versatile artist of his day. The creative compositions in his masterpiece *One Hundred Views of Fuji* travel series seem to have no bounds; where the ancient dream journey painters relied heavily on fantasy, Hokusai's work combined realism and fantasy to bolster the feeling on the part of the viewer of having been there and experienced these adventures. From his lacy-fingered tsunami to his carpenters and fishermen and beach parties, his work is skilled, human, and humorous.

It is said that Hokusai, in reviewing his life, recalled that he had a penchant for copying from the age of six. Though his work was frequently published during his middle years, it wasn't until he was seventy years old that he was really able to fathom the mysteries of nature and felt that his work was finally worthy of notice. He then hoped to continue to achieve a divine state in his art until he reached 110 years, when every dot and every stroke would be alive.

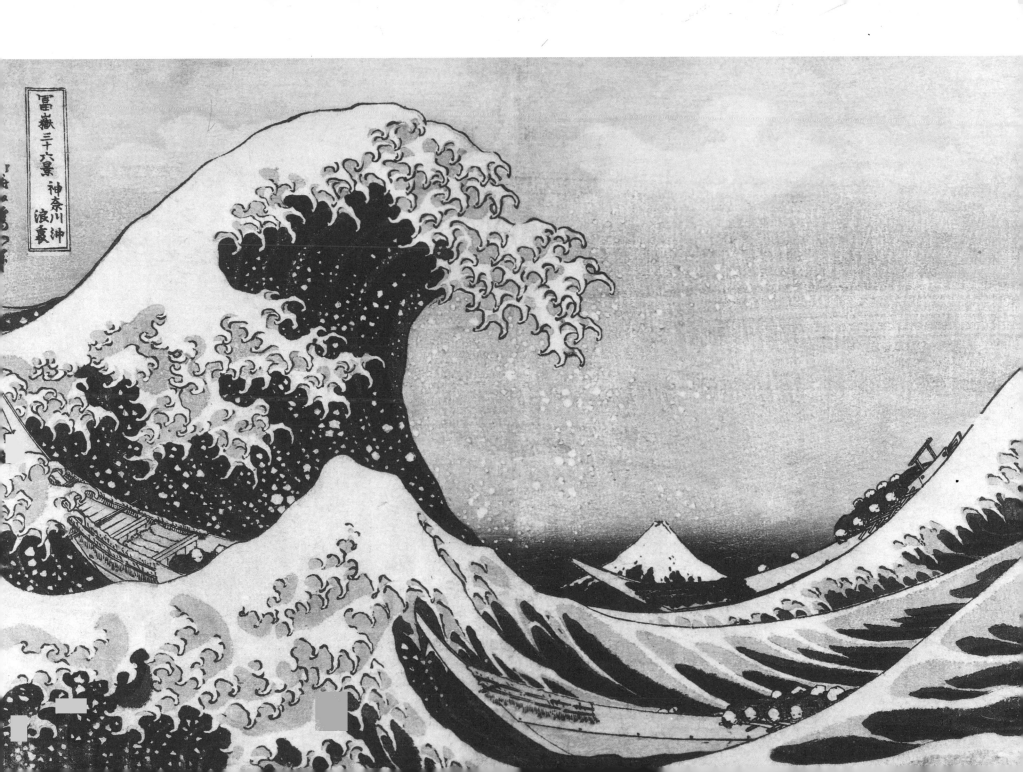

# Starting on Your Own Dream Journey

Whoever you choose as your artistic mentor, it is important to study all aspects of that individual's artistic and personal life. I am awed by Hokusai's love for all of nature's phenomena and his skill to translate that love into beautiful works of art. When I study the varying stages of Hokusai's career, his philosophy speaks to me through his work. I feel as though I can hear him guiding me to start me on my dream journey paintings. I will share with you what he has taught me:

Firstly: Rehearse your sumi-e stroke language daily, so that it will be stored in your artistic memory. Routine memorization of the basics (The Four Gentlemen) will free you to ignite your imagination for your artistic expression.

Secondly: Always compare your brush strokes and the brush stroke groupings that make up the composition of your paintings to the formation of letters, words, and thoughts in fluent writing. Your painting should flow like a story.

Thirdly: Begin your sumi-e day by painting Bamboo and take pleasure in watching your brush drink the wash to the fullest, until it is a beautiful shape—full in the body and tapering to its tip. Place the rich shading with care on the most important part of the brush and take time to think about the angle and direction of the pull, the flow, and the thrust of the strokes according to the emotions of the painting.

Fourthly: Because there is a link between the temperament of artists and the style of their brushwork, practice to master your brush strokes so that you are can control the moods of your painting.

Fifthly: Try to absorb the intricacies of the shape and shading changes that occur in the differently directed pulls. During the flow of your strokes, remember the beauty of sumi-e begins in infinity, is captured on the picture plane, and disappears from the surface back into infinity. It never begins and it will never end.

And lastly: Unite your brush and body in a dance with the sumi-e stroke to maintain your mood throughout the painting. Strive to make each stroke the most beautiful and truthful stroke you have ever painted. You cannot conceal your emotions from the brush, for it will reveal them upon the face of your art.

# Obtaining the Tools

Sometimes, you may hear the tools of brush painting poetically and affectionately described as "The Four Friends" or "The Four Treasures." Simply, this refers to the most basic elements of traditional brush painting—the brush, ink, ink stone, and paper. As a modern brush painter, you need these four supplies, but you can also add modern tools to this list, many of which are easily obtained through mail-order catalogs and on-line stores. Start with the basics and then feel free to add your own tools and find your own way.

## The Brush

Brushes were developed in many cultures thousands of years ago in response to a need for an instrument to place the picture onto the plane. In all societies, brushes were made from the best materials available locally. In Egypt, sacred scribes macerated the ends of reeds gathered on the banks of the Nile. In other parts of the world, artisans attached tufts of animal hair to a handle (a stalk) by means of a ferrule. In Asia, the ferrule was omitted, because people made their brushes from bamboo stalk, which was hollow. The land blessed its people with a natural way to solve their problems. Over the centuries, Asians became ever more skillful in the use of these materials. They mastered the technique of sorting, preparing, and assembling the animal hairs to form the brush head so they could be inserted into a bamboo handle. Because of this process, the Asian brush is an extremely artistic and efficient instrument.

In Japanese painting and calligraphy, there are two main categories of brushes—the round brush or *fude* and the flat brush or *hake*. Because the bristles of both brushes are longer and fuller in the body than those of Western brushes and because they taper to a long, graceful point, sumi-e brushes can be used to make all different kinds and sizes of strokes.

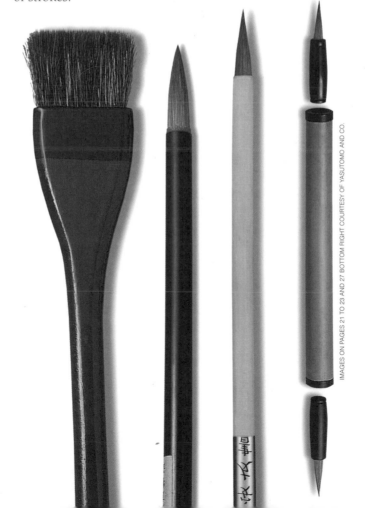

LEFT TO RIGHT: **Hake** *brush with lacquered handle; all-in-one haboku brush; fude-style calligraphy and sumi-e brush; and hideaway fude-style sumi-e brush for sumi-e sketching.*

IMAGES ON PAGES 21 TO 23 AND 27 BOTTOM RIGHT COURTESY OF YASUTOMO AND CO.

The bristles of sumi-e brushes can be a wide range of hairs, including those of sheep, goats, badgers, horses, weasels, deer, and cats. I have read that the hair from Japanese children's first haircuts are sometimes used; and then there is the story of a Chinese artist who saved his cat's perfectly tapered whiskers to make a brush. Another story tells of a Japanese emperor who forbade the use of animal hairs for brushes. Under his rule, an ingenious method of shredding and tapering the ends of bamboo was developed. This style of brush was used until quite recently. I had the privilege of using one when I was in Japan and I loved it!

Considering the wide range of brushes, it is best to simplify them into three basic categories: soft, firm, and hard. Typically, soft hairs are best for spreading color, firm hairs fall into the all-in-one category, and hard hairs are best for accent strokes. I enjoy the all-in-one brush, for it seems to accommodate all of my needs. When making your selection, you should note that all brushes are stiffened for transport with fish glue, which should be washed out gently with warm soap and water before the brush is used.

Since there is a wide range of sizes of brushes, it is best to approach your selection simplistically. You may want to start out with a small, medium, and large brush to accommodate the scale of your painting. However, buying a large range of sizes will probably not be necessary due to the flexibility of the sumi-e brush. I recommend a medium-sized brush, generally a four, five, or six, which works nicely as your all-in-one brush. I have become very attached to my medium-sized *haboku* stroke brush, which is a type of *fude* brush that is made of fine-quality horsehair. I also have a favorite medium-sized *hake* brush, which has a lacquered handle and samba hairs. I have enjoyed this brush for nearly thirty years.

I will state categorically that sumi-e brushes are best for sumi-e. However, Western brushes can fill certain needs. Some manufacturers produce a brush shaped like the sumi-e brushes (both *fude* and *hake*) but with synthetic filaments. This enables artists to use oils and other synthetic paint to create a sumi-e-like painting. When I want to experiment, I enjoy using shader, fan, and liner brushes with synthetic filaments.

*Brush hangers.*

A word of caution about caring for your brushes: Never leave them soaking in water. Rather, you should wash out your brushes gently after each use and either hang them on a hanger or roll them in a bamboo mat. This will allow your brush to thoroughly dry between each use.

## The Ink

In Japanese, sumi means "ink" and the traditional brush painter uses the sumi bar, which must be ground upon a stone with water to produce the ink for painting. According to my first teacher, Sensei Ryukyu Saito, one method of making the sumi bar is to collect soot from burning pine wood, combine it with a glue extracted from fish bones, compress the mixture into a bar, and (if you wish) decorate it in silver and gold with *shodo* and motifs of nature. These sumi bars are works of art in themselves and are a collectable. I own one that is completely lacquered in gold and is so beautiful that I am reluctant to use it. Sumi ink also comes in a liquid form that is more convenient for *shodo* and sumi-e brush stroke practice.

While sumi-e ink is the traditional medium and a natural partner to rice paper, color is exciting and in the modern day, since a multitude of papers and materials are available, a student should experiment with other media. For instance, I have painted with water-soluble ceramic paint on rice paper with delightful results. Nowadays, mail-order catalogs and on-line stores will tempt you with a veritable feast of watercolors. Try them on all your art papers with your sumi-e brush and sumi-e technique. As long as the paints are water-soluble, your sumi-e brushes will tolerate the paint. Just remember to wash and store your brushes carefully when you have finished painting.

## The Stone

The last of The Four Treasures is the traditional stone or *suzuri*, which is used to grind the ink bar. The *suzuri* is usually made from slate. However, other kinds of stone are suitable for use. Your *suzuri* can be a simple rectangular shape or it can be circular with elaborate carvings and covers. If you enjoy collecting, you may find collectible *suzuri* in antique shops. When I grind my sumi bar, I prefer to use a simple rectangular stone.

CLOCKWISE FROM TOP LEFT: *Sumi ink, traditional stone, and Japanese watercolors.*

## The Painting Surface

In Hokusai's time, artists used rice papers, paper screens, silks, earthenware, wood, and metal as their painting surfaces. Therefore, in addition to being on lovely scrolls with rice paper and silk paintings, beautiful brush paintings could be found on lacquered armor, sliding wood and rice paper doors, paper fans, and silk kimonos. Art was all around.

Today, rice paper, which is made from the straw of the rice plant, is still the traditional paper for sumi-e art. Most rice paper comes in shades of white and cream, but some rice paper can be found in vivid colors and interesting textures. While these colored and textured papers are wonderful for collages and painting, they tend to be capricious and delight in torturing the artist by changing their appearance constantly and absorbing unevenly in the drying process. If the artist accepts the whims of the paper and enjoys the adventure, untold mysteries can unfold.

Rice papers vary in texture and range from tissue-quality to blotter-quality. Handmade rice papers are the most desirable, although these are available only during certain times of the year. Fortunately, in these days of mail-order catalogs and on-line stores, exotic rice papers—such as *gasenshi*, mulberry, *hosho*, and others—are just a fingertip away. Traditionally, paintings on rice paper were wet-mounted onto scrolls. However, we can now dry-mount rice paper in a dry-mount machine or we can roll the paper onto a "perfect mount" board with a brayer, which is another form of dry-mounting. Museums seem to be leaning toward displaying scrolls as framed art under glass.

Nowadays, a multitude of nontraditional papers are also available to the sumi-e artist. I enjoy trying all surfaces, including watercolor paper, woodblock printing paper, and even mat board; they all present their special gifts. A good rule of thumb is that any paper with a high rag content will accept the shaded sumi-e stroke with grace. Remember the slicker (less absorbent) your surface is, the thicker your paint will need to be; the more absorbent your surface is, the more diluted your paint will need to be. This general rule, accompanied by artistic common sense, will help you instinctively apply paint onto different surfaces.

Fabrics are yet another painting surface. Silk has always been a favorite for scroll painting, but it is also ideal for clothing art. Velvets, cottons, and all kinds of synthetic materials accept the sumi-e stroke happily. When the appropriate paint is used (in other words it should be identified specifically as "fabric paint"), fabric painting can be another exciting direction for the sumi-e artist, as it allows you to wrap yourself in your art!

Ceramics and porcelain can also display the beauty of sumi-e. The brushwork can be painted on basic greenware, bisque tile, and other glazed surfaces. Naturally, a compatible medium, such as ceramic or china paint, should be used on these kinds of surfaces. In addition, we can add to the long list of painting surfaces materials such as metals, plastics, glass, and fiberglass. While all of these surfaces can be used to create strong results, glass has the extra advantage of being transparent, which invites the painting to be viewed on both sides. Another benefit to using glass is that sumi-e can be combined with the play of light to produce sensational effects.

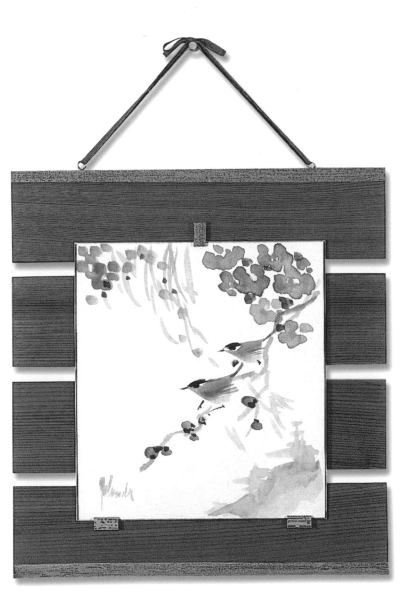

ABOVE: *Dry-mounted rice paper on a shikishi board.*

RIGHT: *This painting is on inexpensive, nondescript paper purchased at a local warehouse.*

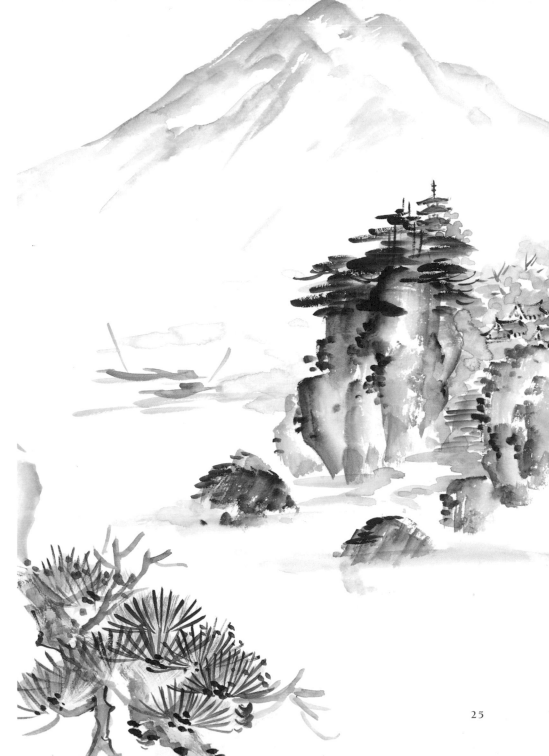

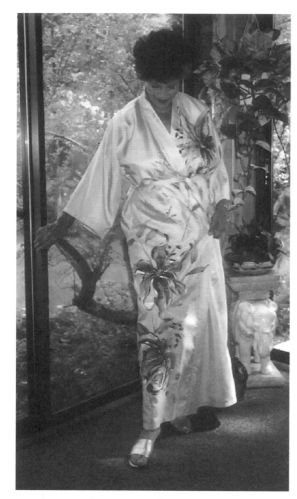

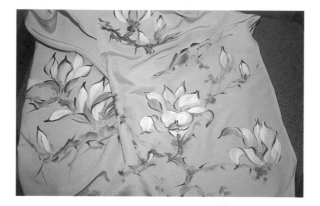

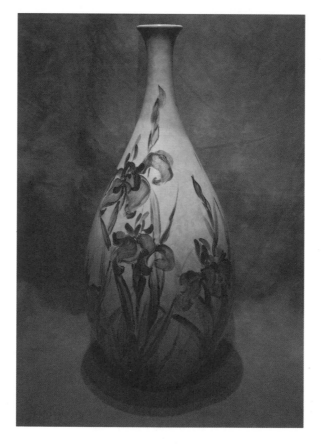

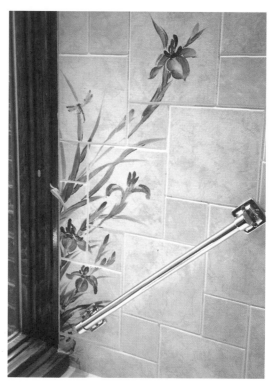

CLOCKWISE FROM ABOVE: *Sumi-e on silk; sumi-e on silk, from the collection of Jan Kent; sumi-e on a ceramic plate, from the collection of Dr. and Mrs. Rhys Harris; sumi-e on bathroom tiles, from the collection of Richard and Louise Arms; and sumi-e on a porcelain vase, from the collection of Tina and Richard McChrystal.*

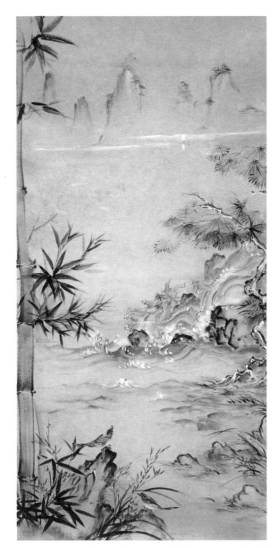
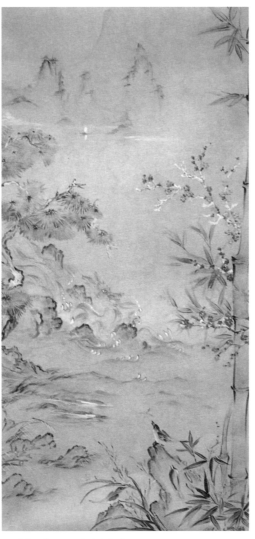

*Sumi-e on a fiberglass panel. Front panel (left) and back panel (right).*
*From the collection of Richard and Louise Arms.*

## .ACCESSORIES

To supplement The Four Treasures, you may want to add these accessories to your list of supplies:

- An absorbent cloth (not a sponge) to draw unwanted moisture from your brush.
- A water container for rinsing unwanted color from the brush.
- A divided palette for separating your colors.
- A divided bowl or dish for varied shades of wash.
- An absorbent felt cloth or blotter to place under your rice paper to absorb moisture.
- A piece of paper to cover your art surface so you will have freedom of stroke and won't have to worry about extending beyond the edge of your painting surface.

Keep all these materials to the right of your painting area, if you are right-handed, or to the left if you are left-handed. This is necessary to avoid any mishaps on the surface of your painting.

LEFT: *A divided palette, also called chrysanthemum dish.* RIGHT: *A divided bowl.*

# Reading the Brush Stroke Language

Sumi-e is the link between drawing and painting. The essence of sumi-e is the use of the four basic stroke-language groups—Bamboo, Wild Orchid, Chrysanthemum, and Plum Branch. Together these strokes are known as The Four Gentlemen. Separately, each group represents a new stroke shape. The four groups are multilayered in that practicing one group gives the sumi-e student insight into the next—until, having practiced and mastered all the groups, he or she is prepared to become a sumi-e ka (ink picture painter).

The process of rendering these stroke shapes can be compared to the childhood process of memorizing the letters of the alphabet to form words and sentences, which facilitate the communication of thoughts and emotions. Perfected through practice, this repertoire of brush strokes enables the visual artist to blend individual strokes into an artistic creation—just as a musician connects individual notes to create melodies and songs. Memorizing the four basic stroke-language groups also enables the artist to have the same fluency as he or she has when writing. Imagine sitting down to "paint" a letter to a friend!

Memorizing The Four Gentlemen has other benefits, too. At the same time as they teach memory painting, they marry control with freedom of stroke expression. Sumi-e painting also helps the student artistically to see mass and depth within the contour line.

An important part of learning The Four Gentlemen is carefully looking at the art of other sumi-e ka. When you study a sumi-e to understand the brush strokes, remember that each stroke is a word. As you examine the piece, remind yourself that you are really reading the brush stroke language. Each shape is logical, caused by the position of the brush, the amount of pressure that was exerted on the brush, and how the brush was pulled or pushed. Even the beginning of the stroke can be easily read by examining the shape and intensity of the shading.

Fostered by many years of study and discipline, a sumi-e ka may complete a sumi-e painting in a few basic brush strokes during the first glow of creativity. Using either monochromatic shading or color washes, the hand, psyche, and brush unite and the act of painting becomes the painting, a poem becomes a picture.

# Bamboo

Logically, a thin stroke is caused when the brush is held vertically so the tip can be brushed across the painting surface. If the stroke thickens in the wrong place, then you have applied too much pressure on the brush in that place. You can build up considerable skill by practicing this stroke. (A)

For a wider stroke, as is required for the bamboo stalk, the brush is no longer held vertically, but rather at a slant. The width of the stroke depends on the slant and size of the brush. If the brush is held at only a slight angle, the stroke will be fairly thin. (B) If the brush is slanted almost horizontal to the paper, the stroke will be as wide as the length of the bristles. The bamboo stalk consists of multiple continuous segments. Paint as many segments as you wish to reach the desired size of the stalk. (C) Bamboo is a major stroke because in order to paint it the student-artist needs absolute control, which will come with practice. (D)

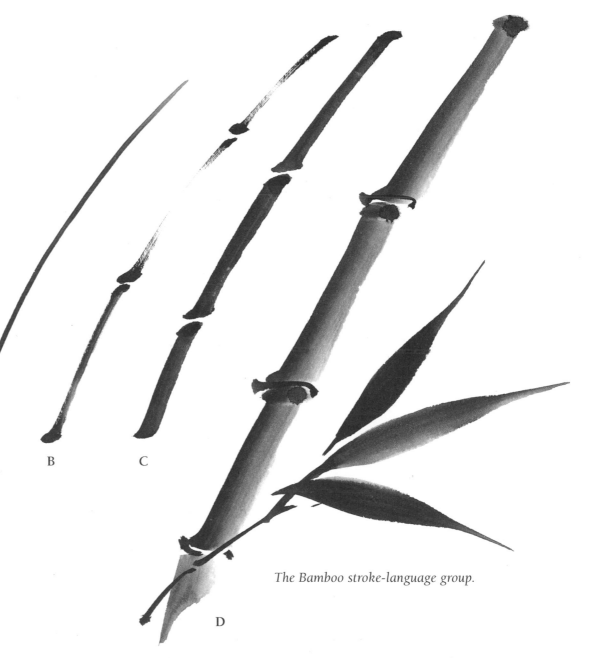

A     B     C

*The Bamboo stroke-language group.*

D

## Wild Orchid

The stroke language becomes very apparent when you read the shapes on the leaves of the Wild Orchid. (A) Each time you change the direction of your moving brush, the shape of the stroke changes. There is no need to turn your paper or twist your brush. Your clever sumi-e brush will create this effect for you!

The stroke language for the petals of the Wild Orchid flowers becomes apparent, too. (B) Turning the brush tip slightly to one side with a slight pressure and changing the direction as the stroke is pulled in the direction of the flower's heart creates subtle changes in the shape, but they will all look as if they belong to the same family. This makes the flower a fine painting rather than a decorative painting. Get into the habit of reading the sumi-e strokes.

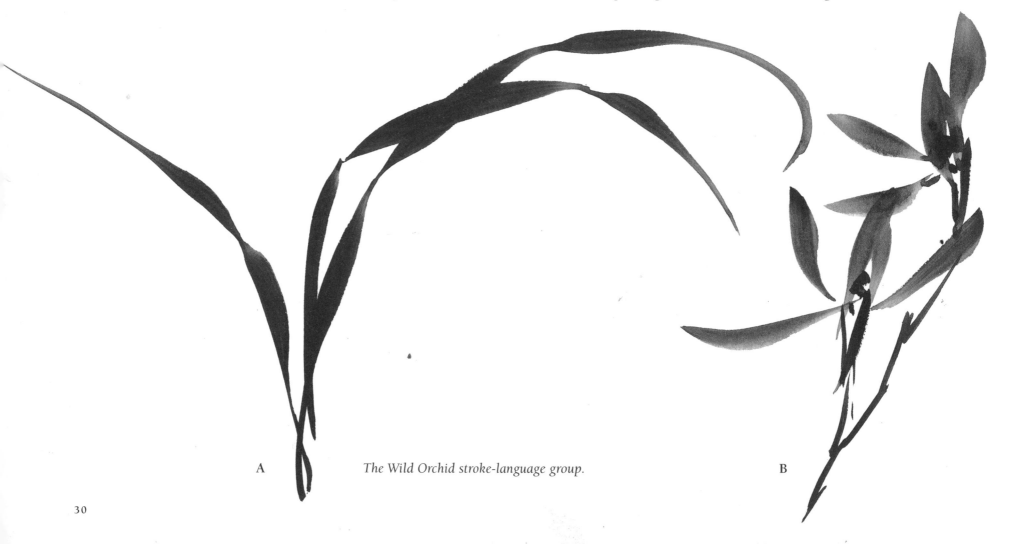

A

*The Wild Orchid stroke-language group.*

B

# Chrysanthemum

The strokes for the petals of the Chrysanthemum flower are almost the same as the strokes for the petals of the Wild Orchid. The major difference is that in order to fit into the heart of the flower, the strokes for the chrysanthemum petals are more curved and thicker or thinner in width than the Wild Orchid stroke. Again, you read where the stroke originates by the shading on the tip of the brush stroke. (A)

When creating the leaves, slant your brush. This will make your brush stroke appear wider, which will not only give it flexibility, but will help you to create different positions both for the leaf and for its accents. (B)

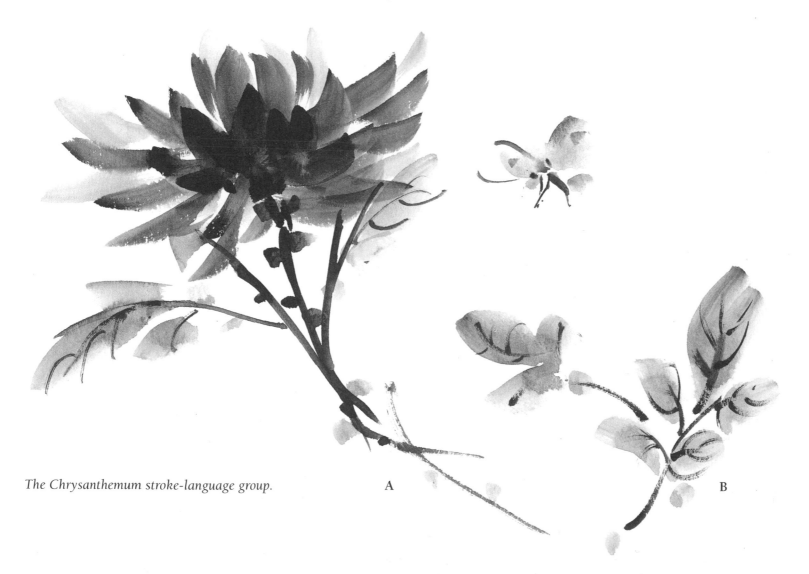

*The Chrysanthemum stroke-language group.*　　　　A　　　　　　　　　　　　　　　　　　　B

31

## Plum Branch

Reading a Plum Branch stroke can be very interesting. Everything depends on the size and slant of the brush, the amount of water in the brush, the intensity and placement of shading, and the "dance" of the strokes. All these elements are needed to create the much-desired effect of "flying whites," which can be seen here on the right of the branch, right before it splits into smaller branches. (A)

Even the blossoms of the plum branch have a language of their own. (B) Sensitivity and fullness of stroke, delicacy of shading, and joy for the budding of the new blossom are the major qualities of this stroke. If you are working with monochromatic washes, the tone of the blossoms should be a delicate gray with accents of rich black. If the buds are grouped, paint an occasional single bud. This will give the joyous feeling that there is more to come.

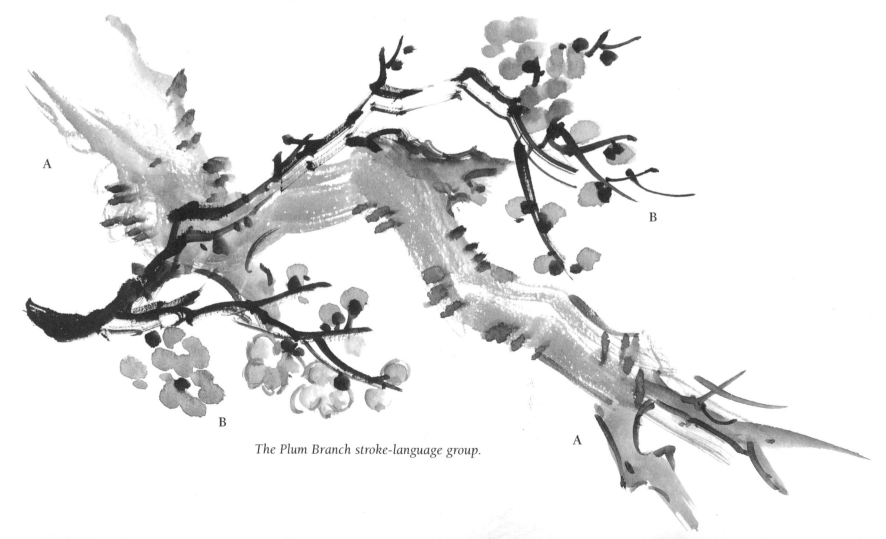

A

B

B

A

*The Plum Branch stroke-language group.*

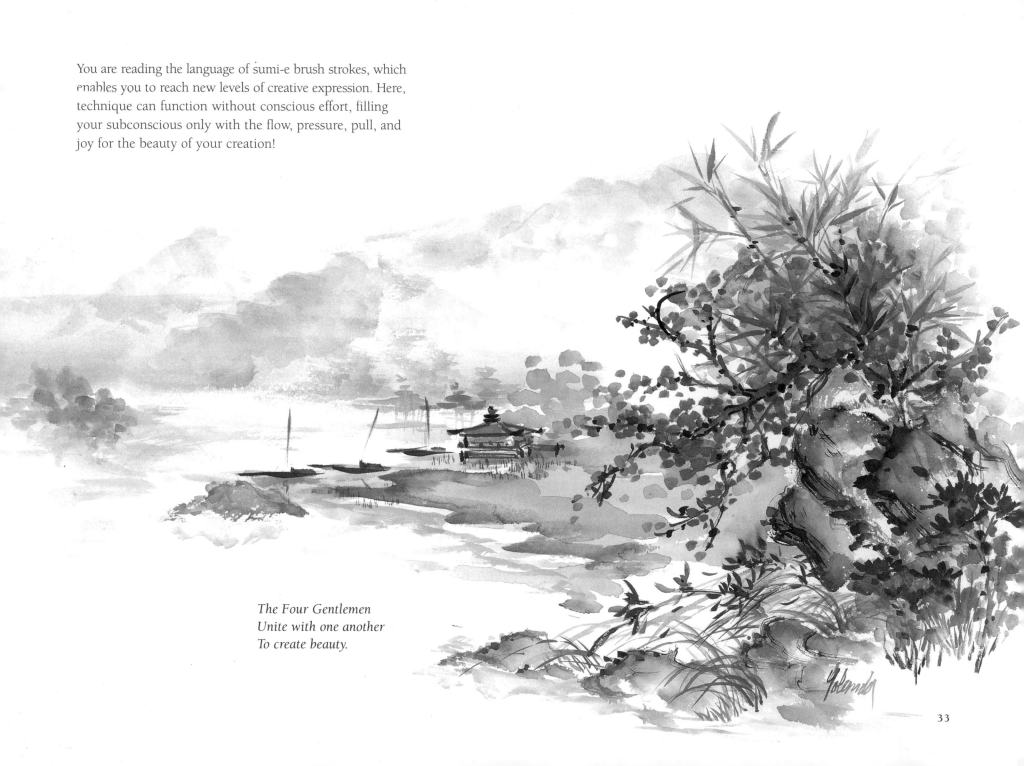

You are reading the language of sumi-e brush strokes, which enables you to reach new levels of creative expression. Here, technique can function without conscious effort, filling your subconscious only with the flow, pressure, pull, and joy for the beauty of your creation!

*The Four Gentlemen*
*Unite with one another*
*To create beauty.*

# Practicing The Four Gentlemen

Asian artists have a saying: "One alias all." This is a distant cousin to our expression: "The whole is greater than its parts." Many of the arts are redolent of this truth. It can easily be seen in comparing painting with music. Consider the four basic strokes—The Four Gentlemen—we have mentioned above. Nowhere is their inner existence more apparent than when these basic strokes are described in terms of a musical composition.

Imagine for a moment The Four Gentlemen as a string quartet composed by some master such as Borodin or Brahms. The first notes of the melodic statement are introduced by the light, sweet notes of the first violin. They paint the melody simply, yet with enough ornamentation to capture the interest of the listener. Next, the second violin joins in, restating the melody in a slightly lower pitch, as does the Wild Orchid stroke, while the first violin—the Bamboo—floats off on its own.

Now the solid old Chrysanthemum, like a sturdy viola, enters the scene, providing an entirely different effect from the delicate upper instruments. It plays the same melody as the first two instruments, but richer and more intricately.

Just when these three have almost completely satisfied the listener/viewer, the somber cello—the Plum Branch of the quartet—makes its dignified entrance and shows how rich the whole composition can be. All four of the elemental modes are woven together in a magnificent contrapuntal masterpiece, the simplicity of which is its complex structure.

Fill your mind with the strokes, shapes, and actions of The Four Gentlemen. Absorb the instructions and practice them until they are completely automatic, as in writing. When your technique can function smoothly without conscious effort, you may realize that you have been observing the whole picture plane and not just the strokes you have been painting. At this point you will be starting to naturally include compositional sophistication and emotional input into your work. Even after these strokes and their groupings are completely automatic and can be seen in their "mind's eye," serious sumi-e ka tune up these skills at the start of each painting session, just as athletes tune up their muscle coordination and powers of concentration in preparation of their performance.

# Bamboo

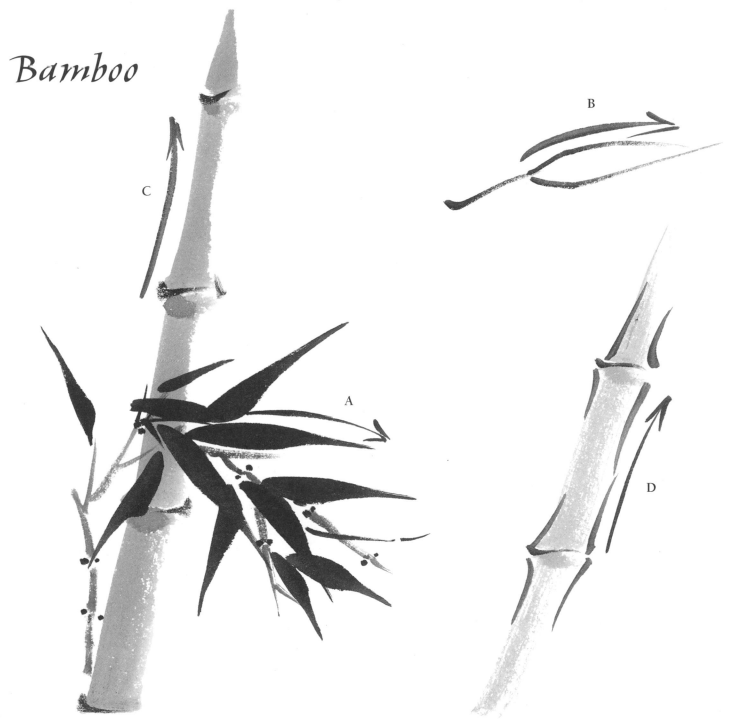

**BAMBOO LEAF:**

A With an upright brush, drag the tip to create the stem. Without lifting the brush, press it and then pull it up and away with a spirited but thoughtful swing to create the leaf. B Note the shape of the leaf.

**BAMBOO STALK:**

C With a brush slanted at about a 45-degree angle, press down deliberately at the beginning of the stroke, then pull for the majority of the stroke, and finally end the stroke with a press motion. Repeat this motion until the desired length of the bamboo stalk is reached. D Note the shape of the bamboo stalk.

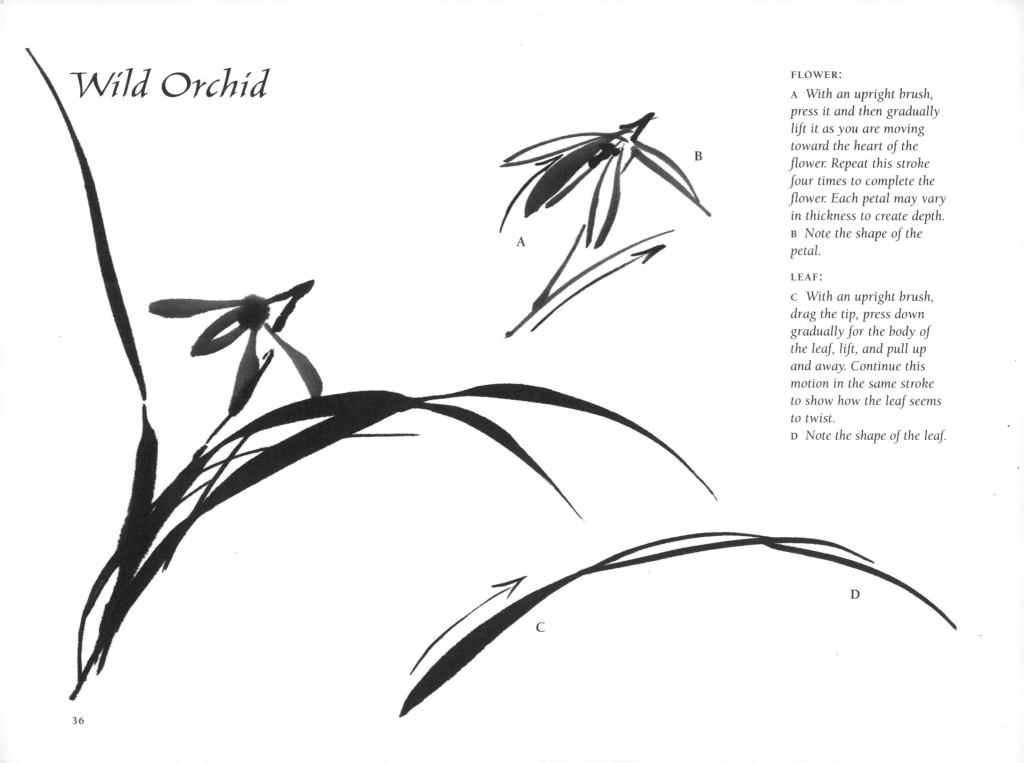

# Wild Orchid

**FLOWER:**

**A** With an upright brush, press it and then gradually lift it as you are moving toward the heart of the flower. Repeat this stroke four times to complete the flower. Each petal may vary in thickness to create depth.
**B** Note the shape of the petal.

**LEAF:**

**C** With an upright brush, drag the tip, press down gradually for the body of the leaf, lift, and pull up and away. Continue this motion in the same stroke to show how the leaf seems to twist.
**D** Note the shape of the leaf.

# Chrysanthemum

A

B

**FLOWER:**

A  *With an upright brush, press the tip and pull the stroke, lifting as you approach the heart of the flower. Add more petals to enhance the body of the flower.*
B  *Note the shape of the petal.*

**LEAF:**

C  *With a slanted brush, stroke in the lobes of the leaf and then accent them with the vein stroke.*
D  *Note the shape of the leaf.*

C

D

# Plum Branch

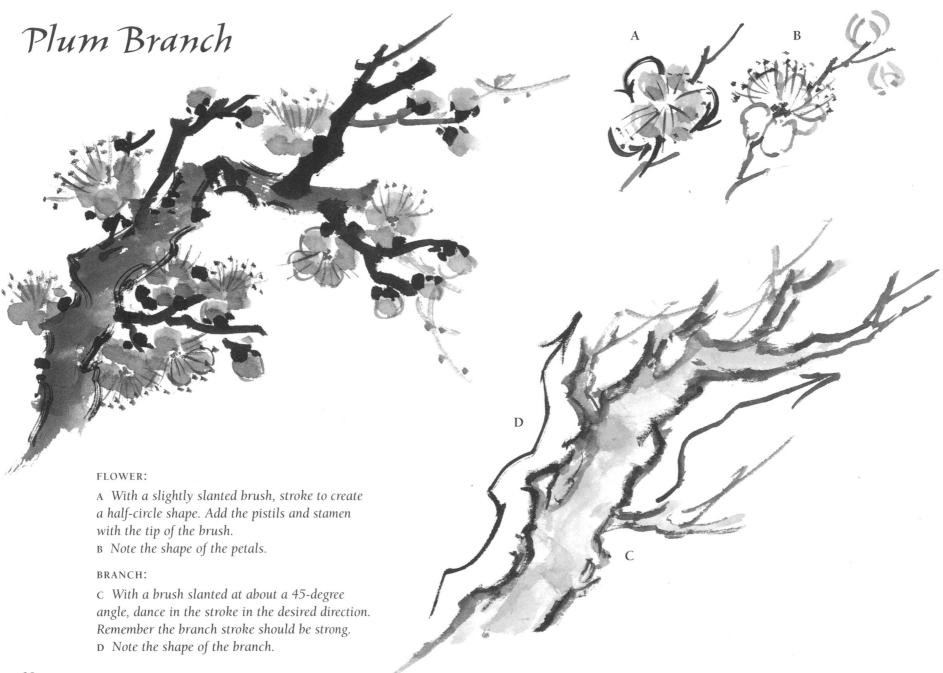

A

B

**FLOWER:**

A *With a slightly slanted brush, stroke to create a half-circle shape. Add the pistils and stamen with the tip of the brush.*

B *Note the shape of the petals.*

**BRANCH:**

C *With a brush slanted at about a 45-degree angle, dance in the stroke in the desired direction. Remember the branch stroke should be strong.*

D *Note the shape of the branch.*

D

C

## SOME NOTES ON CHARGING THE BRUSH

The amount of wash (diluted paint or ink) absorbed by the sumi-e brush differs according to the kind of support that you use. In addition, certain kinds of paper—especially rice paper—can be affected by weather. In humid weather, rice paper tends to absorb dampness so you can charge your brush with less wash. In dry weather, the brush performs better with more wash. In order to make your brush strokes flow smoothly, the body of the brush must absorb enough wash to swell it to a pliable shape, making it sensitive to all the brush stroke pressures.

After charging the brush with wash, I wipe the tip against the water container to control its shape. Be aware that the sumi-e brush holds more fluid than the Western-style brush. It may also help to dab your charged brush against an absorbent cloth to remove excess wash. Many watercolorists who use Western-style brushes shake their brushes to rid them of excess moisture before they begin to paint.

Thick paint or dry ink is useful for accent strokes, contour lines, and blended strokes on paper with a polished or hard surface. For a painting that seems to require a strong accent, make sure the paint is neither too light nor too watery. An accent that is too light will cause the painting to lose its impetus. It can determine the success or failure of your work.

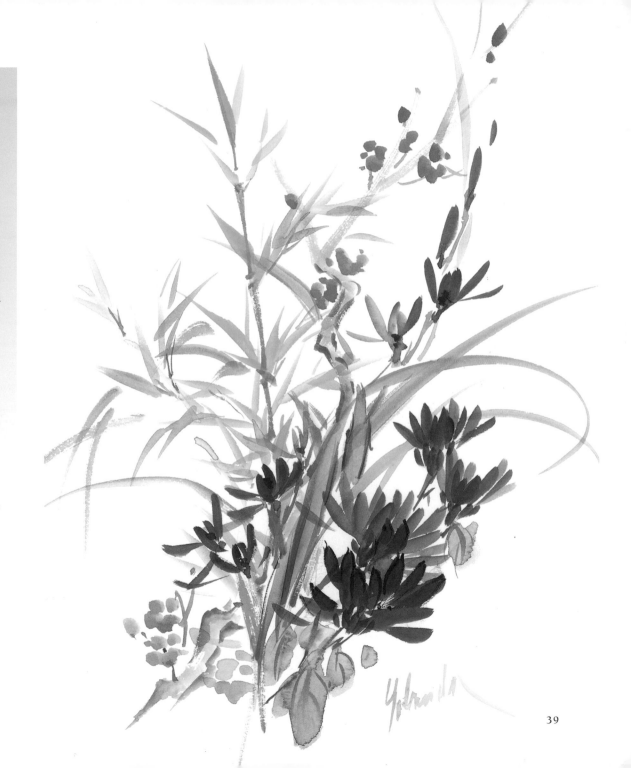

# Beginning the Creative Process

In the art of sumi-e, the time-honored method of copying your teacher's art is recognized as the best way to memorize the basic strokes. This method is respected in the Far East, and quite often the teacher will allow a talented student to combine his or her signature with the student's signature. This chapter contains a number of examples to guide you into discovering a multitude of combinations of the various strokes. I would be honored if you tried to copy these compositions, keeping in mind that this process is for helping you find your way.

There are lots of different places to turn to for inspiration. One option is to find compositions in books on Asian art. Each master has something to offer. You may even find inspirational material on kimonos, ceramics, and fans. If you are near an Asian grocery store, look at the commercial art on food labels. Often there are beautiful examples of sumi-e and *shodo*. Try to copy them, too.

There comes a time when constant copying and practice alone becomes repetitive and nonproductive. Even before you are completely confident in your ability to create the basic strokes, try stimulating the creative process by combining classic compositions and some advanced subjects. This can help you seek a personal style and find other ways to discover unusual compositions.

I find studying insects to be very fruitful. Insects are a good balance to natural compositions and can present a whole new world of strokes. No two insects are repetitive in shape and design. Even the lowly ant can stimulate new inspiration. The strokes for most insects can be found in The Four Gentlemen, especially Bamboo. See what you can find.

# Incorporating The Four Gentlemen

After one has practiced the basic strokes to the point at which they are automatic, it is important to start to think about how to incorporate The Four Gentlemen and the many related strokes. With sumi-e each element is important. Even little blades of grass can make a composition complete and different.

Taking care at this stage in your artistic development can expand your painting vocabulary in amazing ways. The goal is to create interesting compositions with the strokes that you have mastered. And studying well-rendered paintings will be the key to your success. Again, inspirational sumi-e paintings can be found in any number of places. Carefully comb through museums, galleries, and catalogs, but don't rule out alternative sources. I once bought a marvelous shower curtain because it had a lovely print of Bamboo, Wild Orchid, and Chrysanthemum. It gave me such pleasure!

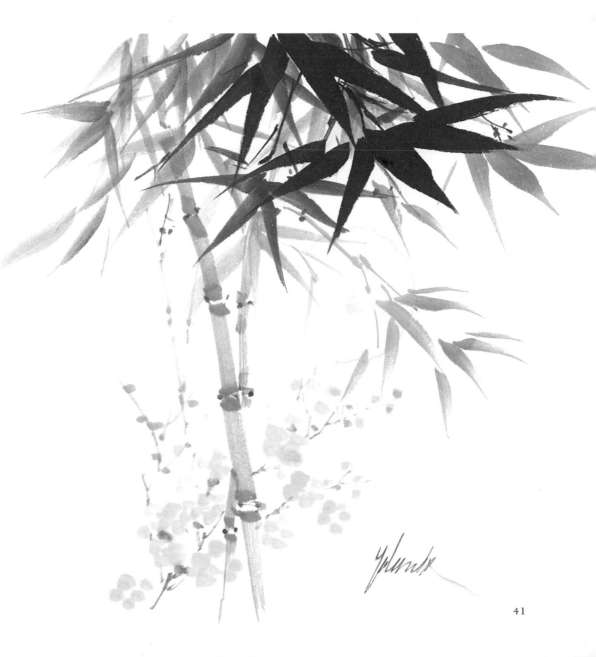

### Bamboo, Plum Branch, and the Moon

"AND SOME SAY THAT LADY LI OF THE FIVE DYNASTIES PERIOD, TRACED THE SHADOWS OF BAMBOOS THROWN ON A WINDOW BY MOONLIGHT AND THIS MARKED THE BEGINNING OF BAMBOO PAINTING IN INK."

—MAI-MAI SZE, *THE MUSTARD SEED GARDEN MANUAL OF PAINTING*

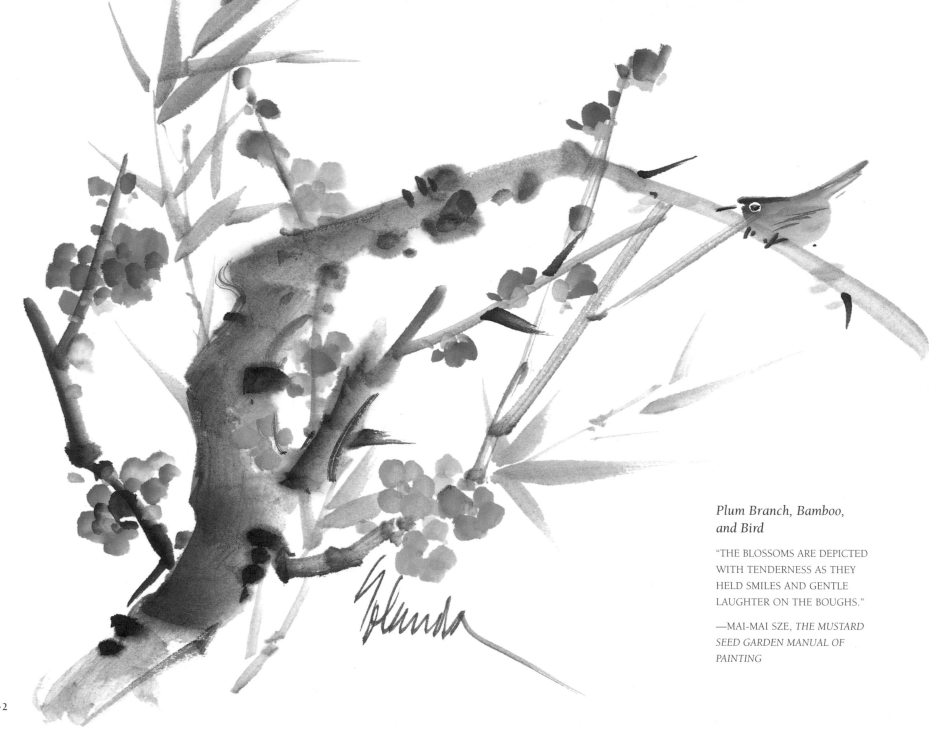

### Plum Branch, Bamboo, and Bird

"THE BLOSSOMS ARE DEPICTED WITH TENDERNESS AS THEY HELD SMILES AND GENTLE LAUGHTER ON THE BOUGHS."

—MAI-MAI SZE, *THE MUSTARD SEED GARDEN MANUAL OF PAINTING*

## Wild Orchid and Plum Branch

"IN A LIGHT MOOD ONE SHOULD PAINT THE ORCHID, FOR THE LEAVES OF THE ORCHID GROW AS THOUGH THEY WERE FLYING AND FLUTTERING, THE BUDS OPEN JOYFULLY, AND THE MOOD IS INDEED A HAPPY ONE."

—MAI-MAI SZE, *THE MUSTARD SEED GARDEN MANUAL OF PAINTING*

43

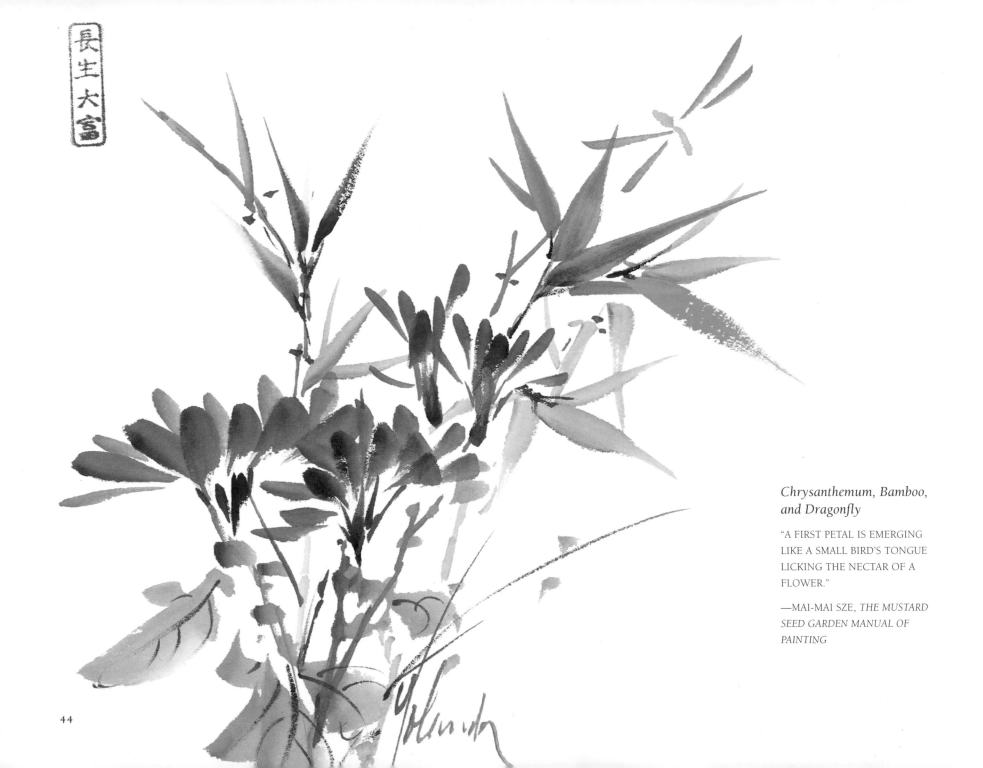

*Chrysanthemum, Bamboo, and Dragonfly*

"A FIRST PETAL IS EMERGING
LIKE A SMALL BIRD'S TONGUE
LICKING THE NECTAR OF A
FLOWER."

—MAI-MAI SZE, *THE MUSTARD
SEED GARDEN MANUAL OF
PAINTING*

44

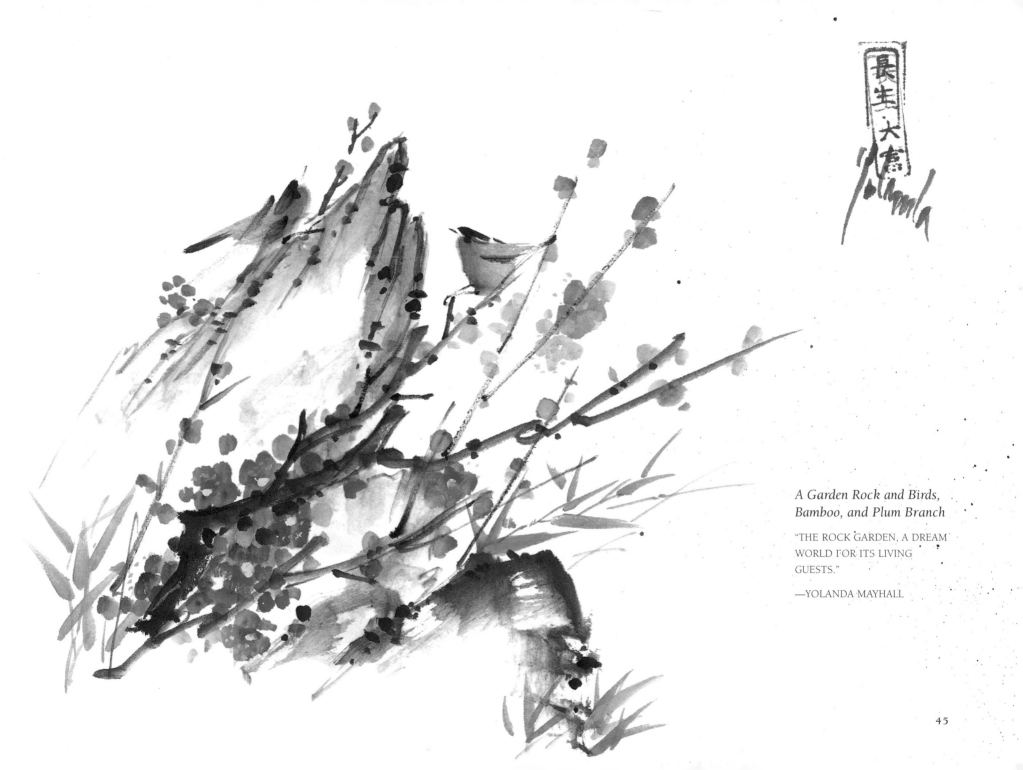

*A Garden Rock and Birds, Bamboo, and Plum Branch*

"THE ROCK GARDEN, A DREAM WORLD FOR ITS LIVING GUESTS."

—YOLANDA MAYHALL

45

# Learning Advanced Brush Strokes for Birds and Flowers

While you can learn a great deal from studying the Four Gentlemen, there comes a time in your brush painting education when you must move into advanced strokes. A multitude of subject matter that would involve these strokes surrounds us. Sometimes it is almost hard to choose a good advanced subject. We are surrounded by so much beauty.

Japanese artists take special pleasure in finding good advanced strokes in their subjects and they often seem more successful if they find subject matter with an interesting story. It may sometimes feel like it is difficult to find new subjects because most strokes seem to be related to The Four Gentlemen. Indeed, an ancient Chinese artist once noted: "If you can paint The Four Gentlemen, you can paint anything in creation." However, I enjoy subject matter that moves away from the basics because I feel that these can challenge and expand our artistic horizons.

Some of my favorite advanced subject matter includes the Yo Bird, the Iris, and the Hummingbird. To me, the strokes for these three subjects seem related to each other because they call for larger, softer shapes. They also offer new opportunities for creating compositions with fascinating stories.

# The Story of the Yo Bird

In studying the works of my Japanese *sensei*, I have become more and more aware of the importance of mass, depth, and line in the strokes of brush painting. One dreamy spring morning in Virginia, following my return from Japan, I was preparing to start my warm-up strokes of Bamboo when my attention was drawn to a flock of birds fluttering around my bird feeder. They reminded me of the birds that one of my teachers had painted.

Sensei Ryukyu Saito was a gentle and talented artist who had a great sensitivity for birds and he painted his sparrows with a free technique that bordered on impressionism. Because my Japanese and his English were limited, he taught me by demonstrating. First, he painted birds in the linear style, articulating the beak, head, body, etc. Then he created a bird in his own unique style. From this demonstration, I gathered he wanted me to find my own style. But his delicate illustrations also showed me the importance of perceiving mass and depth within the contour area.

That dreamy spring morning, as I started my usual Bamboo practice, I saw that one of the leaf strokes that I had painted looked like a bird's body. The stroke had already been made, but I had no idea how I had painted it! I tried to reconstruct the stroke—alternating the pull, the pressure, and the angle of my brush. After what seem like an eternity, I rediscovered my original creative accident and my "Yo Bird" was born.

When I creatively pulled the bamboo leaf stroke in various directions, I could see that this stroke would work for almost all of the birds' positions as they were fluttering around. The living brush!

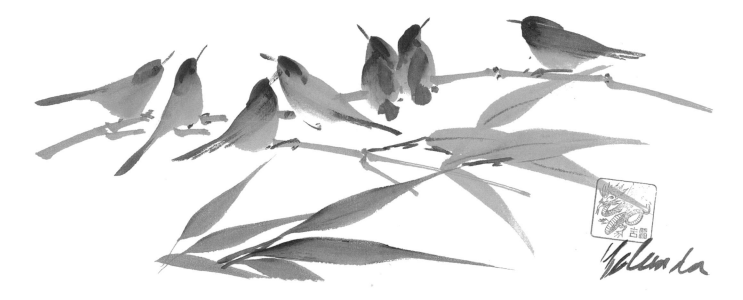

47

When you are practicing The Four Gentlemen at the beginning of each painting session, ask yourself: Do my strokes show mass and depth within the contour line? When you are painting a bird and stroking in its body, ask yourself: Do my strokes have full, soft strength? Does my sumi-e bring back emotional memories? Did any of my strokes suggest other forms?

Sometimes—because of an incorrect pull or pressure on the brush—a bird stroke that is not quite correct will look like a fish stroke.

How fortunate! A creative accident!

Even a stroke that may seem like a mistake can open doors to other strokes. Whenever I am practicing The Four Gentlemen, I pay close attention to the possibilities of my mistakes. Likewise, I urge my students to do the same and to read them carefully.

Your "mistake" may be another kind of stroke—and you will remember it because you made the discovery yourself. Now whenever I see birds fluttering around the feeder, I can visualize them in my "Yo Bird" stroke language. This enables me to paint them from my artistic memory in almost all of their positions. Whenever I paint these birds, I thank my teacher for his gentle tutoring.

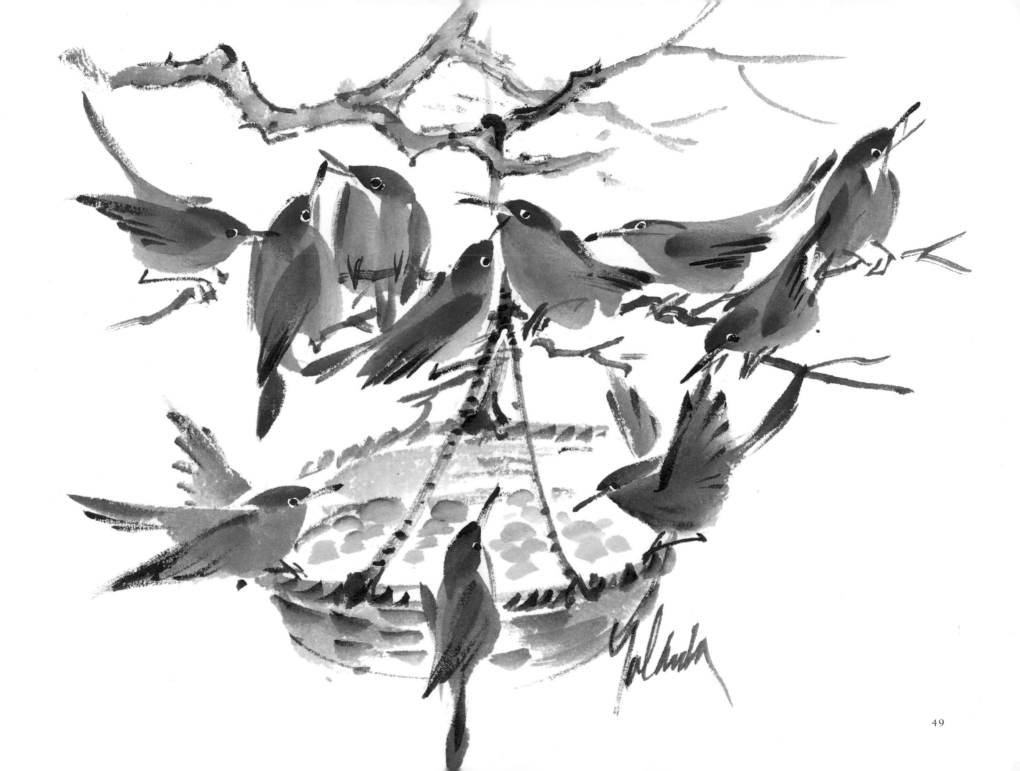

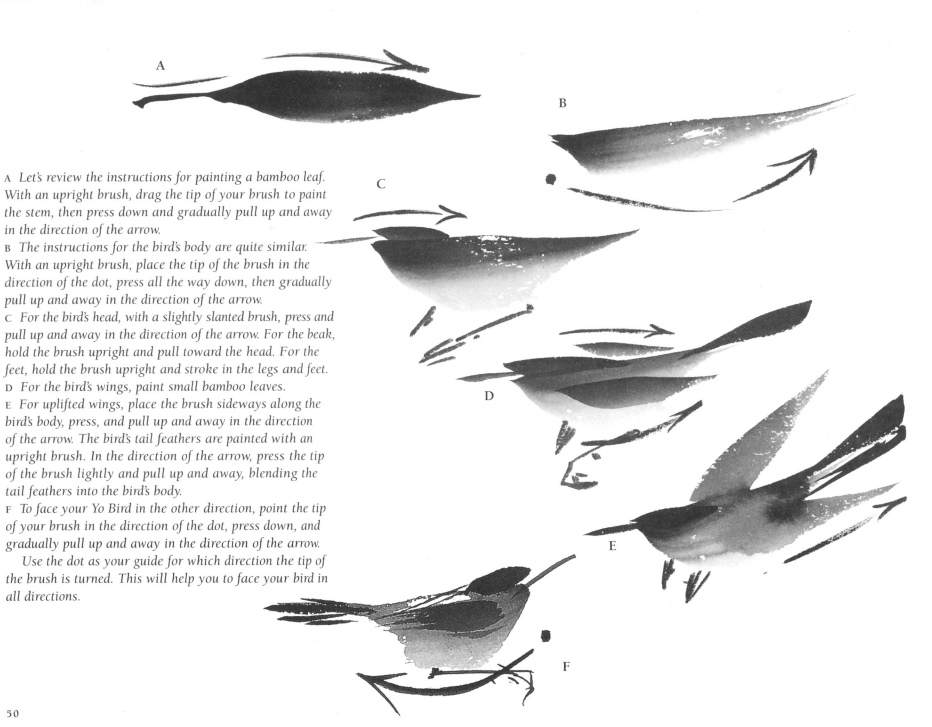

A Let's review the instructions for painting a bamboo leaf. With an upright brush, drag the tip of your brush to paint the stem, then press down and gradually pull up and away in the direction of the arrow.

B The instructions for the bird's body are quite similar. With an upright brush, place the tip of the brush in the direction of the dot, press all the way down, then gradually pull up and away in the direction of the arrow.

C For the bird's head, with a slightly slanted brush, press and pull up and away in the direction of the arrow. For the beak, hold the brush upright and pull toward the head. For the feet, hold the brush upright and stroke in the legs and feet.

D For the bird's wings, paint small bamboo leaves.

E For uplifted wings, place the brush sideways along the bird's body, press, and pull up and away in the direction of the arrow. The bird's tail feathers are painted with an upright brush. In the direction of the arrow, press the tip of the brush lightly and pull up and away, blending the tail feathers into the bird's body.

F To face your Yo Bird in the other direction, point the tip of your brush in the direction of the dot, press down, and gradually pull up and away in the direction of the arrow.

Use the dot as your guide for which direction the tip of the brush is turned. This will help you to face your bird in all directions.

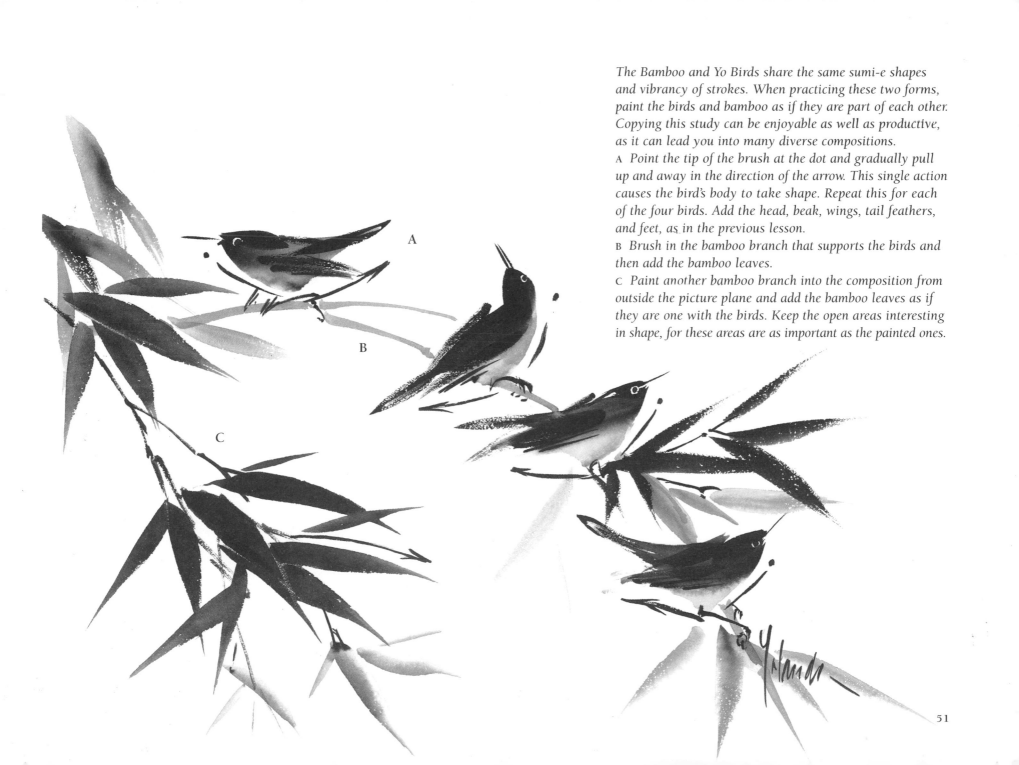

The Bamboo and Yo Birds share the same sumi-e shapes and vibrancy of strokes. When practicing these two forms, paint the birds and bamboo as if they are part of each other. Copying this study can be enjoyable as well as productive, as it can lead you into many diverse compositions.

A  Point the tip of the brush at the dot and gradually pull up and away in the direction of the arrow. This single action causes the bird's body to take shape. Repeat this for each of the four birds. Add the head, beak, wings, tail feathers, and feet, as in the previous lesson.

B  Brush in the bamboo branch that supports the birds and then add the bamboo leaves.

C  Paint another bamboo branch into the composition from outside the picture plane and add the bamboo leaves as if they are one with the birds. Keep the open areas interesting in shape, for these areas are as important as the painted ones.

# The Story of the Enchanted Iris

Over the years the iris has had special significance in many cultures—from being cultivated for its medicinal and cosmetic properties to inspiring textile and jewelry designers and artists. The iris's eternal beauty and grace has been passed down through the centuries. In ancient Egypt, irises were carved on the walls of the Temple of Amen-Re at Karnak. In Greek mythology Iris is the goddess of the rainbow, the peace between warring gods, the leader of women's souls into the Elysian Fields. During the Crusades, Louis VII discovered irises growing in Egypt and he adopted their form as a heraldic emblem on his coat of arms. Known at first as "le fleur de Louis," this stylized rendition of the flower eventually became known as "fleur-de-lis."

Likewise, this magical flower has taken hold of the imagination in Japanese culture. In ancient Japan, May 5 was known as Boys' Festival Day. On this day some families took baths infused with iris leaves and hung the sword-like leaves on their gates and eaves in the belief that their strong fragrance would ward off evil spirits and illness. The iris and its leaves became the symbol for the Boys' Festival Day. Some modern families continue this custom.

In 1948 the Japanese government changed the name of the holiday to Children's Day. This is the day that parents honor their children.

The iris's beauty has also inspired artists throughout the ages. One notable example is the Japanese artist Ogata Kōrin's painting of an iris water garden, called *Iris and Bridge,* which he painted in 1694. This six-panel gold screen is lavishly decorated with indigo blue irises that have veridian green leaves. The painting is highly skilled and beautifully rendered with a daring composition. It is elegance personified!

Another, very different example, is Vincent van Gogh's oil painting *Iris* of 1890. Van Gogh's flowers resemble an Asian one-stroke approach that has been enhanced with an exciting accent line. It is almost as though he gathered an armload of irises, thrust them into a vase, and passionately painted them to try to capture that moment. Van Gogh is known to have admired Japanese art.

The iris fills us with admiration regardless of how it is rendered—for this flower also naturally lends its form to sumi-e.

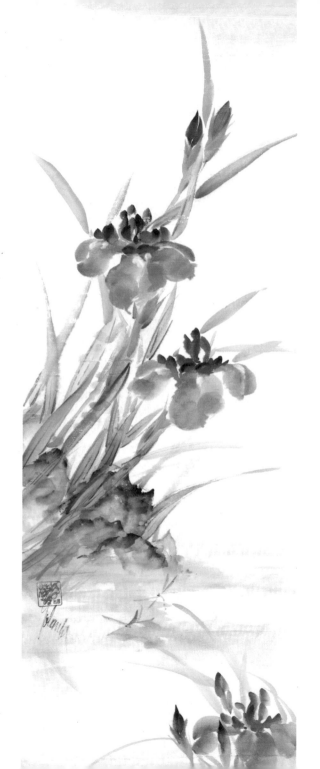

# Elegant Iris

The Irises,
Their petals damp, are fragrant.
Listen! The cuckoos
Are calling now, this rainy
Evening in May.

by fujioara no Yoshitsune 1169 - 1206

*Yolanda and Ted Mayhall,* THE PICTURE OF ELEGANCE.
*From the collection of Brenda NcNeal.*

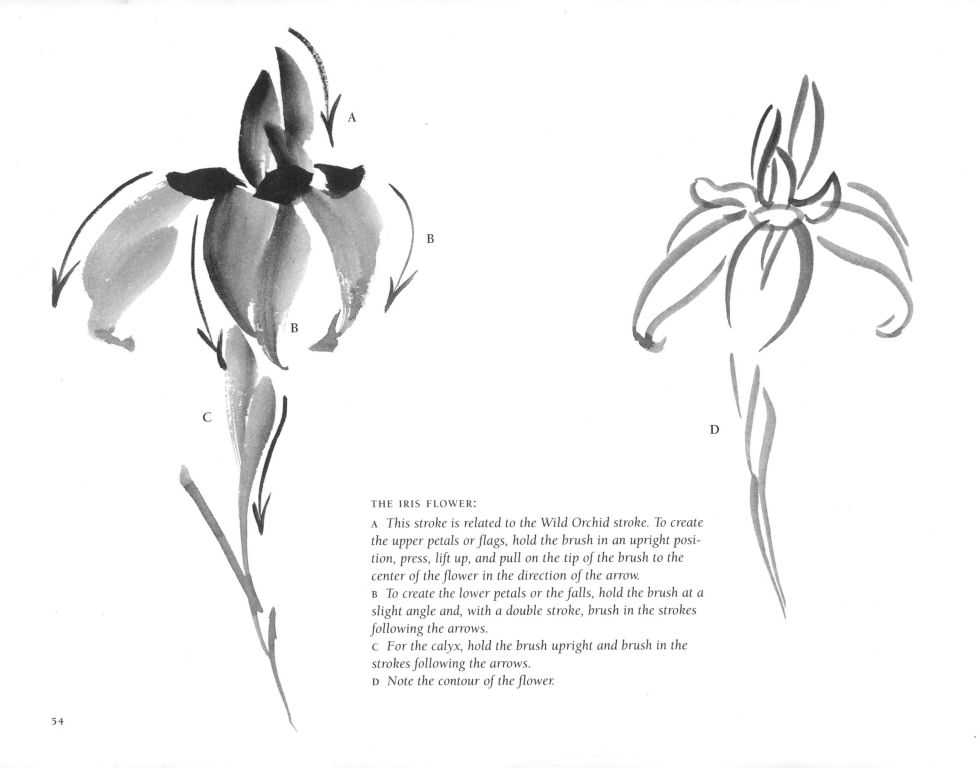

**THE IRIS FLOWER:**

A  *This stroke is related to the Wild Orchid stroke. To create the upper petals or flags, hold the brush in an upright position, press, lift up, and pull on the tip of the brush to the center of the flower in the direction of the arrow.*

B  *To create the lower petals or the falls, hold the brush at a slight angle and, with a double stroke, brush in the strokes following the arrows.*

C  *For the calyx, hold the brush upright and brush in the strokes following the arrows.*

D  *Note the contour of the flower.*

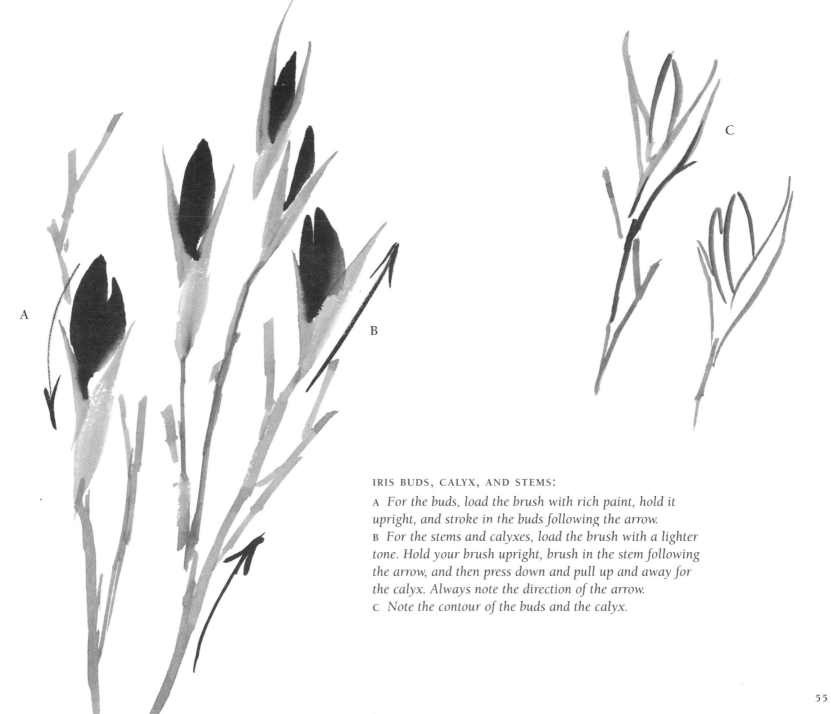

**IRIS BUDS, CALYX, AND STEMS:**

A *For the buds, load the brush with rich paint, hold it upright, and stroke in the buds following the arrow.*

B *For the stems and calyxes, load the brush with a lighter tone. Hold your brush upright, brush in the stem following the arrow, and then press down and pull up and away for the calyx. Always note the direction of the arrow.*

C *Note the contour of the buds and the calyx.*

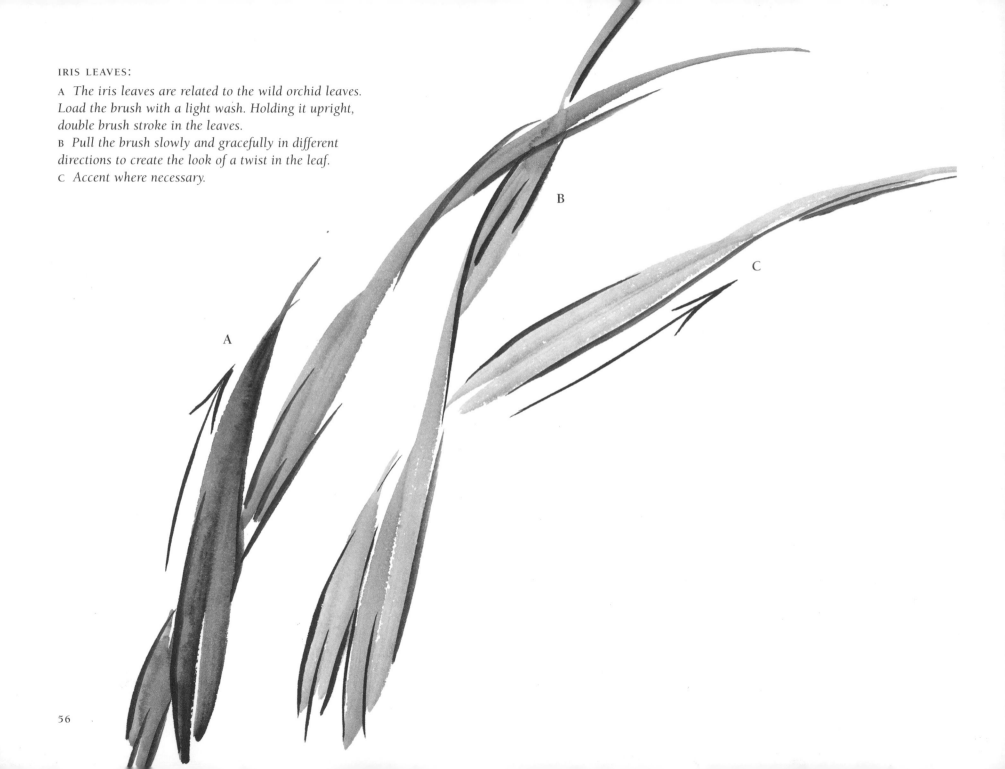

**IRIS LEAVES:**

A *The iris leaves are related to the wild orchid leaves. Load the brush with a light wash. Holding it upright, double brush stroke in the leaves.*

B *Pull the brush slowly and gracefully in different directions to create the look of a twist in the leaf.*

C *Accent where necessary.*

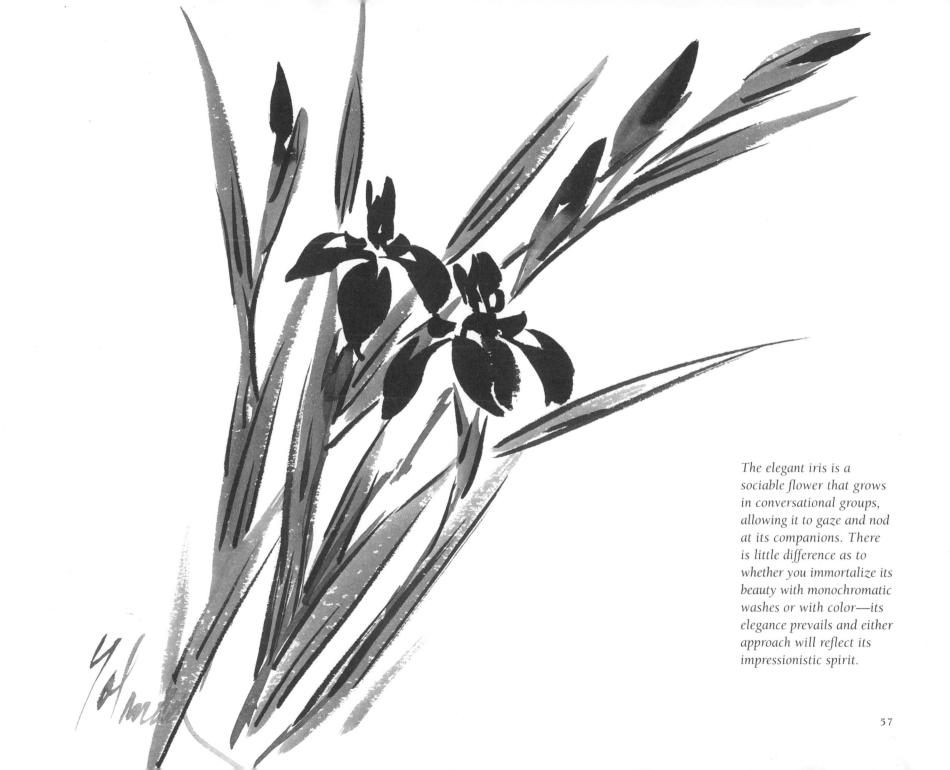

The elegant iris is a sociable flower that grows in conversational groups, allowing it to gaze and nod at its companions. There is little difference as to whether you immortalize its beauty with monochromatic washes or with color—its elegance prevails and either approach will reflect its impressionistic spirit.

# The Story of the Hummingbird and Its Flowers

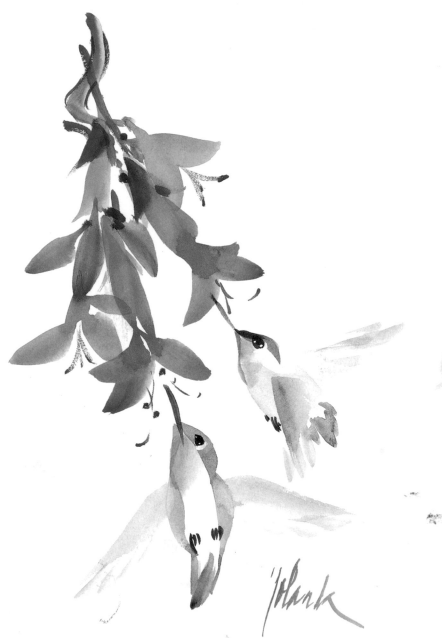

If you are charmed by the hummingbird, you need to know that there are 338 different types, all of which have their own dazzling array of feathers. Hummingbirds are certainly worthy of research and study, but if you decide to paint them, try to stay true to the sumi-e spirit and render them as you see and feel them.

The brush strokes used to paint hummingbirds are the same as those used for the Yo Bird. The basic stroke for the body mass, head, wings, tail feathers, and feet are much the same with both birds, but they may differ in color and markings. The archetypal hummingbird has a small body, large wingspread, large eyes, and tiny feet. Their long, slender bills are designed to siphon nectar from deep flower blossoms. While they are generally seen in flight, they do sometimes rest on tree branches. I once witnessed a flock of hummingbirds hovering over my dogwood trees when they were in full bloom.

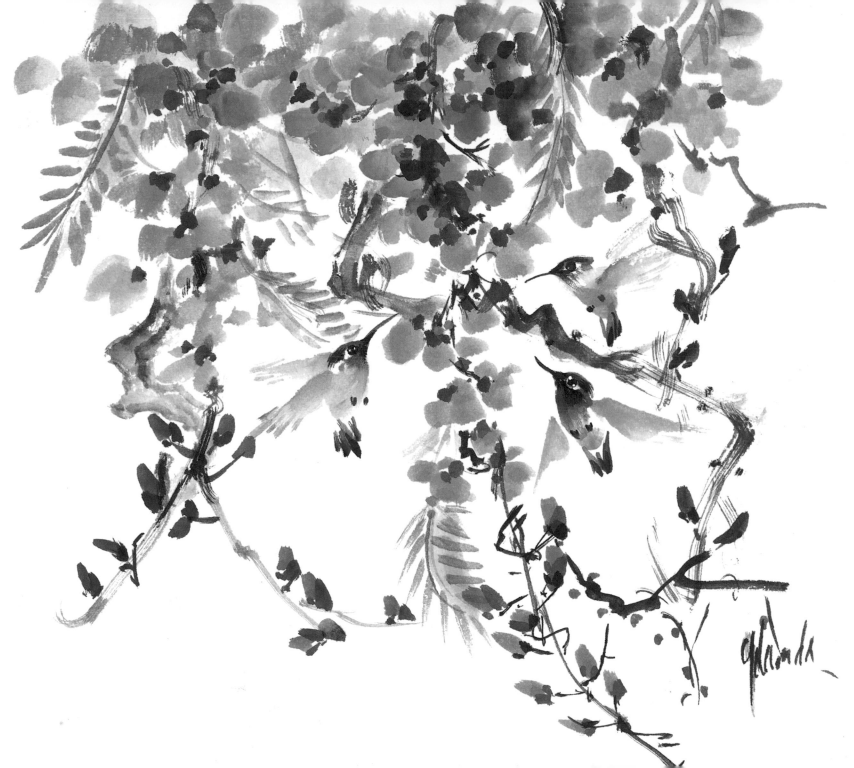

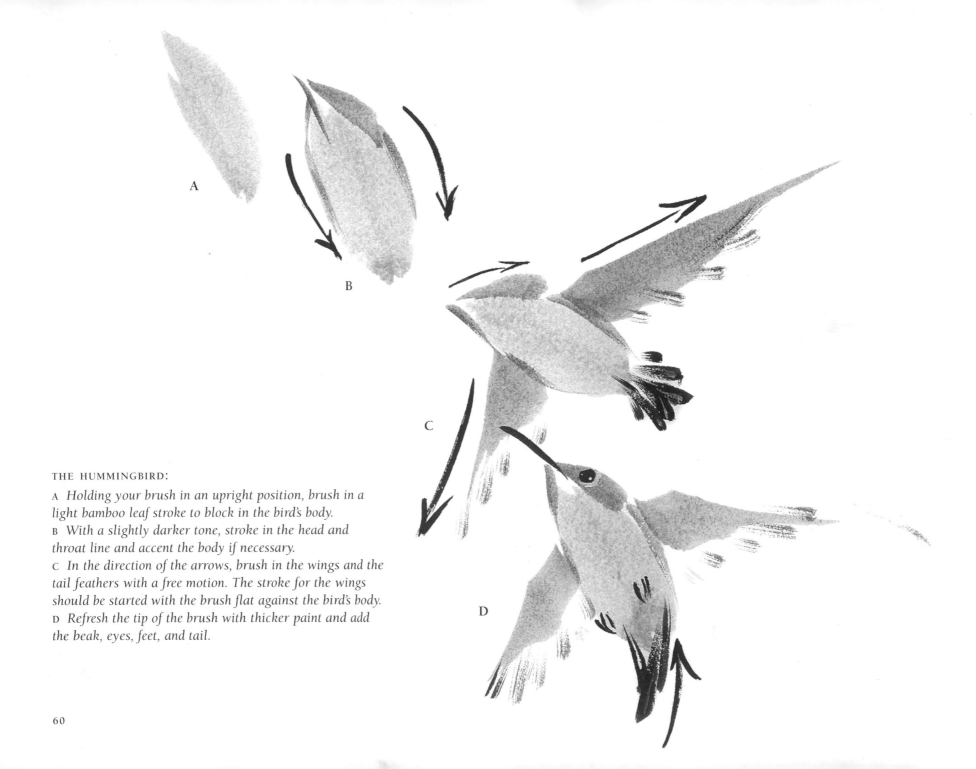

**THE HUMMINGBIRD:**

A *Holding your brush in an upright position, brush in a light bamboo leaf stroke to block in the bird's body.*
B *With a slightly darker tone, stroke in the head and throat line and accent the body if necessary.*
C *In the direction of the arrows, brush in the wings and the tail feathers with a free motion. The stroke for the wings should be started with the brush flat against the bird's body.*
D *Refresh the tip of the brush with thicker paint and add the beak, eyes, feet, and tail.*

60

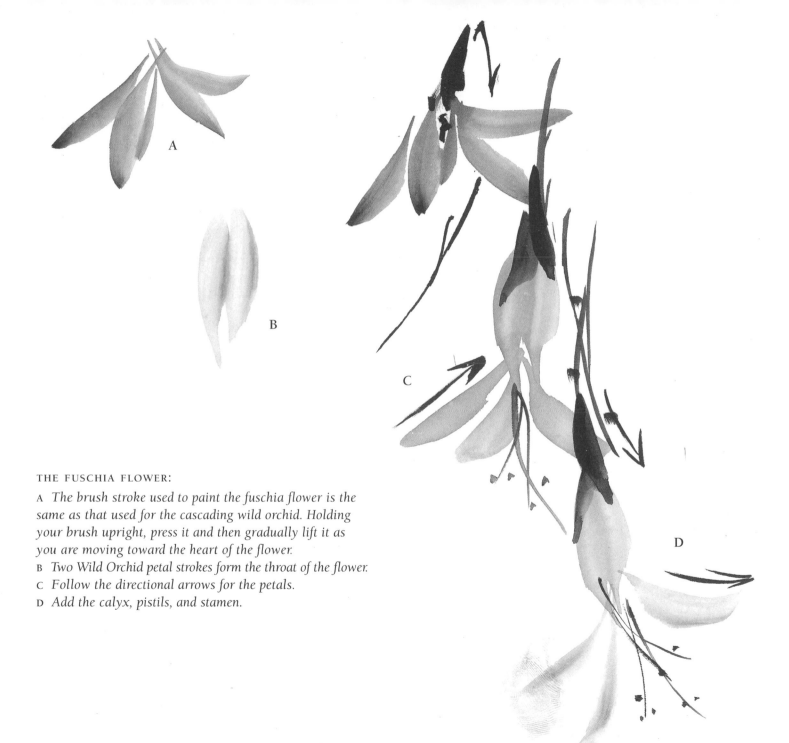

A

B

C

**THE FUSCHIA FLOWER:**

A  *The brush stroke used to paint the fuschia flower is the same as that used for the cascading wild orchid. Holding your brush upright, press it and then gradually lift it as you are moving toward the heart of the flower.*

B  *Two Wild Orchid petal strokes form the throat of the flower.*

C  *Follow the directional arrows for the petals.*

D  *Add the calyx, pistils, and stamen.*

D

# Internalizing the Three Essential Elements of Sumi-e

It is impossible to create an idea or an illusion without composing its elements. By the same token, it is impossible to compose the elements of an illusion without identifying its creative idea. It is unlikely that a composition will be effective if the origin, the idea, does not appear in the design. Therefore, the most important factor for your dream journey is the balance of creativity, composition, and either ink or color or the combination of the two.

Creativity wells from many sources. For some it comes from nature; for others religion; still others group relationships. Wherever you garner your creativity, always remember that it will be your most important companion for dream journey paintings.

Art must come from the life experiences and the spirit of the artist. If this criterion is met, composition—which is a full partner with creativity on the dream journey adventure—comes into its own. The flexible composing of a sumi-e can be very exciting, for the artist is not tied to traditional methods. In sumi-e the unpainted areas of a composition are given as much respect as the painted areas. Again, without composition there is no creativity, for an arrangement must be present to stage your creativity.

The third component, color, is key to sumi-e, even with the traditional, so-called monochromatic genre of this art. When the sumi bar is first ground the ink will be jet black. However, as it is carefully diluted with water, a variety of tones will appear, all of which will suggest colors. And then there is the more experimental form of sumi-e, which incorporates color through placing paint on selected parts of the brush (not upon a palette). This specialized technique allows the colors to blend freely as the brush stroke flows.

With the unity of creativity, composition, and color (or the illusion of color), dream journeys become possible.

# Sumi-e in Creativity

We were created to create. As a sumi-e artist you are working in two dimensions—length and width—to accommodate the picture place. In order to complete the full circle, you are also seeking depth, time, color (or the feeling of color), and inspiration to stimulate creativity.

Artistic inspiration is all around us. A lifetime of inspiration can be found on simple walks anywhere within your reach—even if you live in the city. Daily walks are good for many reasons. They exercise your mind and body and perhaps exercise your pets. They also nourish your creativity. You can absorb nature's special projects in your own time, with either a fleeting glance or with slow absorption. I take my two pups for a walk on the same roads twice a day, morning and evening, and it's amazing how interesting repetition can be. For instance, on my walks I am storing information about how pine trees grow; how the trees lean according to the wind currents; the arrangements of the branches and the texture of their needles, long and soft or stubby and prickly to the touch; and how they are accompanied by their cones. The same trees seem to change from bright green with sprinkles of diamond dew in the morning sun to black-green in the evening, when the trunks appear to absorb the orange gold of the setting sun.

After my walks, sometimes I record and brush-sketch my impressions in my memory book to help me recall subjects for future sumi-e paintings. Again, I am amazed at how interesting repetition can make things, for nothing stays the same. Everything changes constantly according to the weather, the time of day, and the seasons—even in Florida. Sparks of interest are always added to the scenery, too. Today, I studied a mosquito hawk (southern dragonfly), as she flirted with my pups.

Once, on one of our evening walks, we found a lone ladybug on a leaf. Her brilliant orange body gleamed like a jewel and we tenderly carried her back to our garden, hoping she would make her home with us.

*Mosquito Hawk*

*Ladybug*

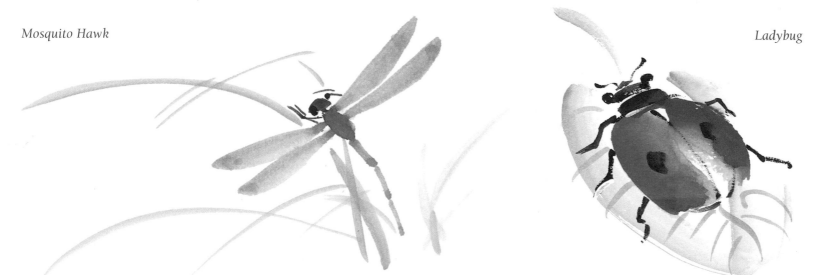

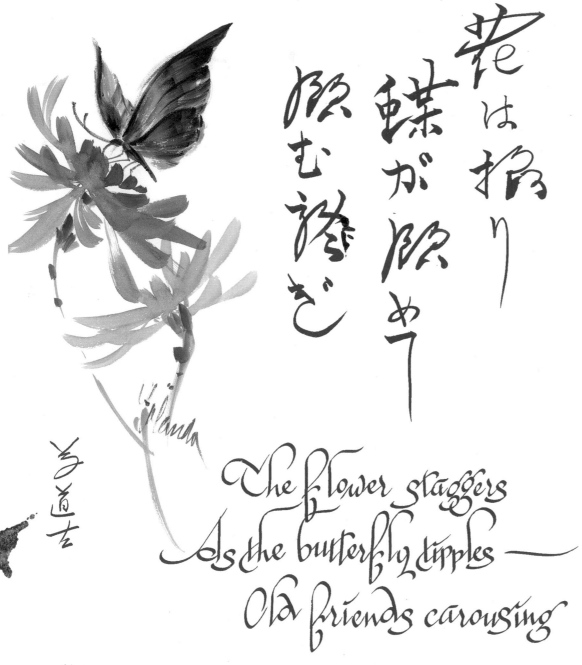

花は揺り
蝶が限や
限む諸ぎ

The flower staggers
As the butterfly tipples —
Old friends carousing

Early one morning after strolling through my garden, I noted and sketched this moment into my memory sketchbook: A butterfly, with wings fluttering, lighted on a flower and they trembled together. The memory of this relationship inspired this poem and the sumi-e and *shodo* art.

Although you may sketch an impression for future use, remember that the sketch is just a reminder of a memory. This sketch will enable you to re-create the ultimate sumi-e—that is, a painting of your emotions. Sketches are palettes of memories to stimulate your creativity for your dream journey paintings.

*Haiku and calligraphy by Ted Mayhall.*
*From the collection of Robin and Pete Grega.*

## SURIMONO

Sumi-e measurably improves with correct and consistent practice. Daily discipline helps sumi-e painting become as natural as an additional language, which makes it as easy to paint a sumi-e as to write a letter. But there is an added benefit of daily practice, too—the creation of *surimono*.

Hokusai communicated with his followers by means of *surimono*, which translates as "printed things." They were special woodblock prints, probably made on 8 × 7-inch cards, that were cherished by all. These cards started a fad that lasted far into the nineteenth century. I like to think that modern greeting cards were inspired by *surimono*.

Hokusai's *surimonos* were personalized commissioned works of art and never sold commercially. They ranged from invitations to private and public functions to the all-important New Year greetings. These greetings are still a tradition in Japan.

My husband and I communicate at holiday time with our family, friends, and patrons by means of sumi-e *surimonos*. This practice inspires me to discover new subject matter, fresh color combinations, and a myriad of new inspiration. Most important, they are a constructive way of practicing without the danger of monotony.

65

THE WITHLACOOCHEE RIVER

*In the gathering twilight, the twisted trees*
*seem to take on spectral shapes.*
*From the collection of Sandra Gerhard.*

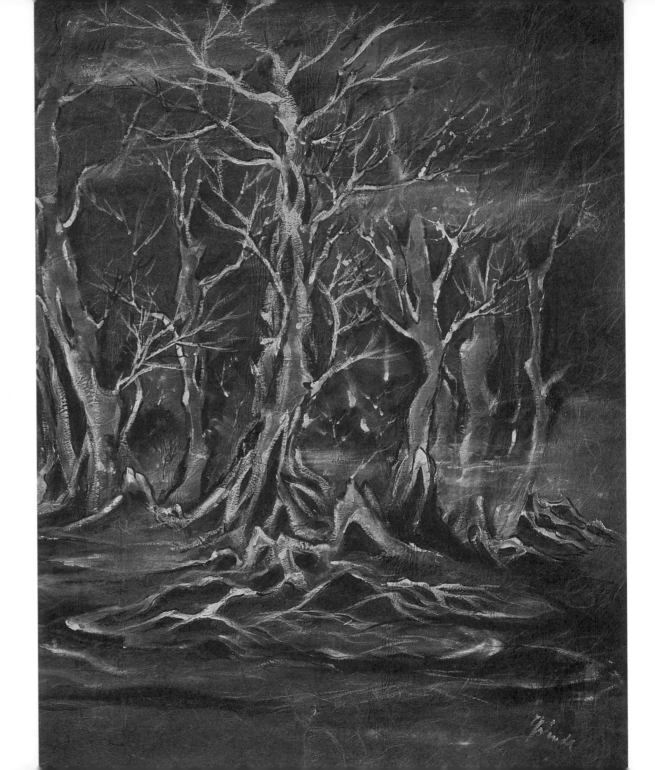

66

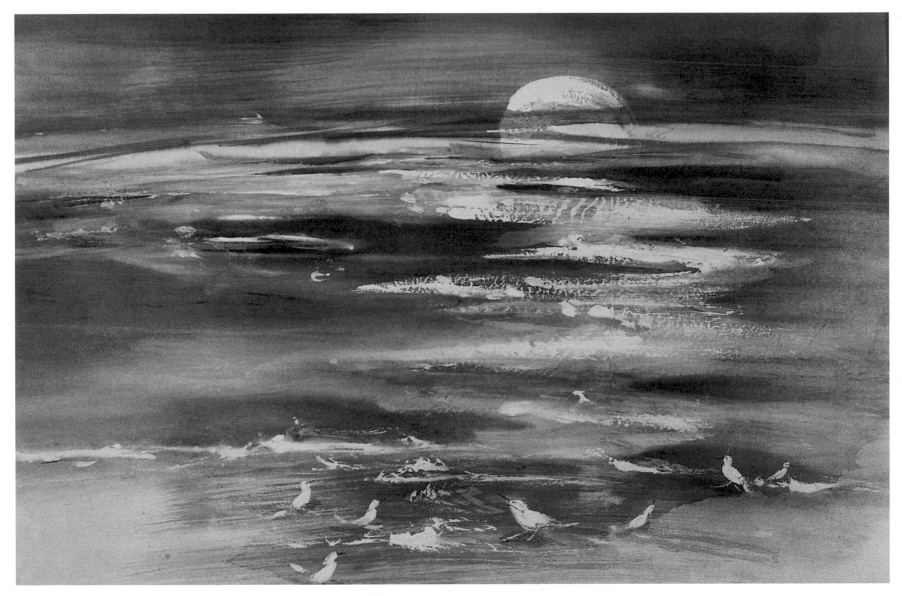

THE PLAYGROUND

*This is a creation that was inspired by a memory long ago. The sky and water seem to be one and the beach birds are playing with the surf.*
*From the collection of Mr. and Mrs. Robert Hess.*

# Sumi-e in Composition

In studying Hokusai's work *One Hundred Views of Fuji*, I realized that he excelled in unusual approaches to composition and it made me decide that there are no bad compositions in sumi-e—as long as the artist remembers that the beauty of the subject is pulled from one side, captured upon the picture plane, and allowed to flow off into infinity. A strong foreground, medium middleground, and a soft background with suitable corresponding brush strokes shows simple sumi-e depth. It's such a reasonable and simple plan.

Proper treatment of open (negative) space can balance a painting. This space can take on many forms—such as sky, water, mist, or even just a space for a poem, written signature, or chop (the logo of the artist). Placement of the chop varies according to the artist's wishes. However, this is an important component of Asian art, as it has allowed researchers to trace the history of Asian artists throughout the centuries.

Open space can also be used effectively to incorporate a written reflection of the moment. How exciting it is to find comments by the artists that were made on the day the painting was created. It is as if the ancient artist is speaking directly to you! Vincent van Gogh was intrigued by Ando Hiroshige's woodblock print that depicts farmers in straw capes struggling against rain on a bridge. So he painted an oil version of this scene and embellished it with his thoughts.

Color or tone for these open spaces is not necessary, but it is often employed. Sometimes, however, the stage for a night scene can be set with a moon or a night bird, rather than with physical darkness. Alternatively, strongly contrasted tones dressed with shadows can suggest moonlight. The suggestion of water can be created with floating things—such as water lilies and their pads, water-walking insects, waterfowl, and even boats—all complete with reflections. In sumi-e less is more.

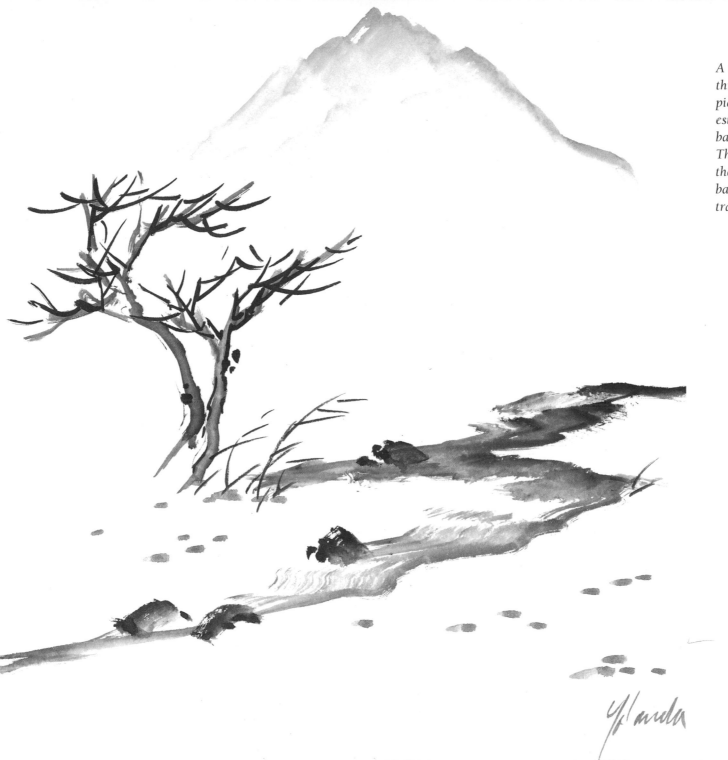

*A river snaking its way through the middle of the picture plane creates interesting contours for the banks on the other side. The negative areas take on the feeling of snow. The bare trees and animal tracks complete the story.*

Yolanda

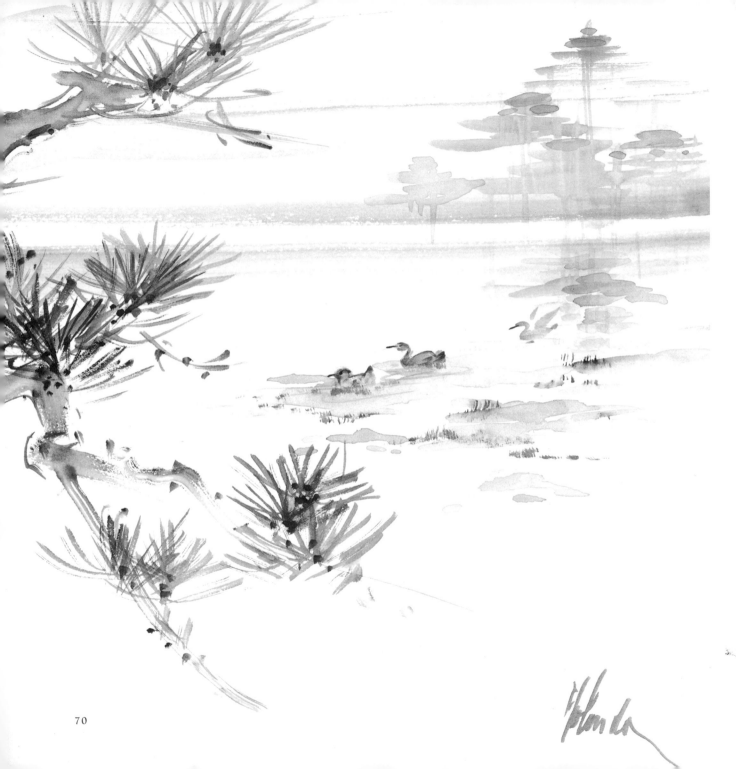

LEFT: *This composition shows how a lead stroke can pull the viewer into the painting. In this instance, the stroke originates outside and left of the picture plane. Water is suggested by floating vegetation and waterfowl.*

OPPOSITE: *By contrast to the image on this page, this picture's strong area is on the right side of the painting. Remember that the desirable open areas can be used for a salutation, poem, chop, or signature—or a combination thereof. The boats create the illusion of water.*

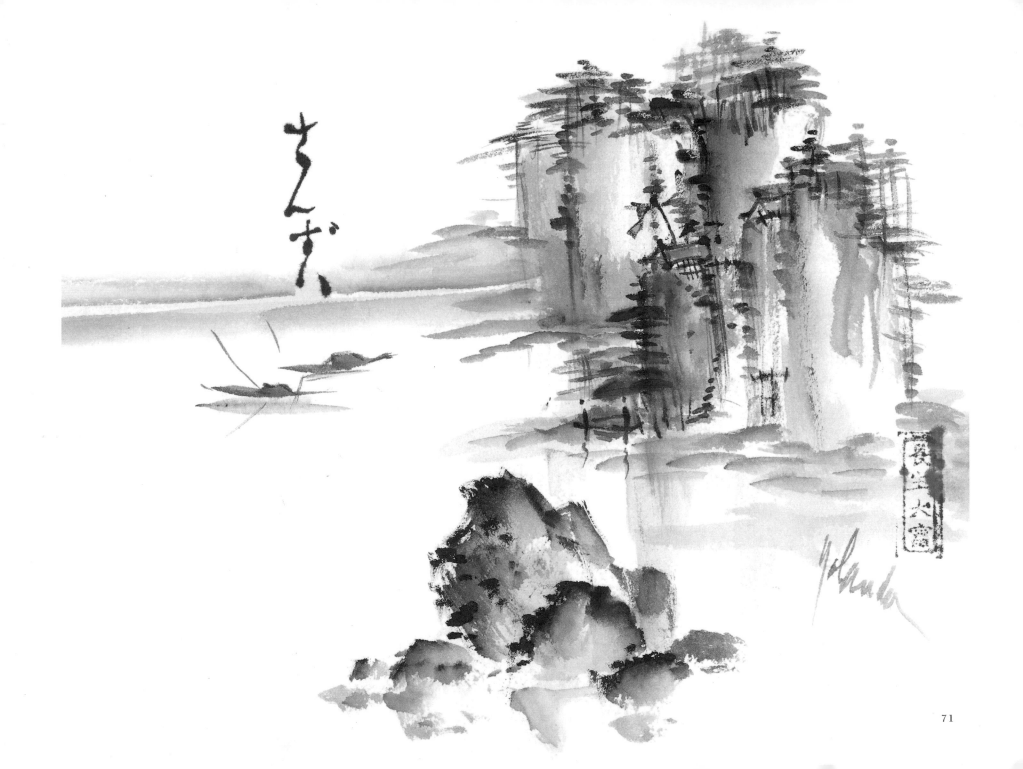

71

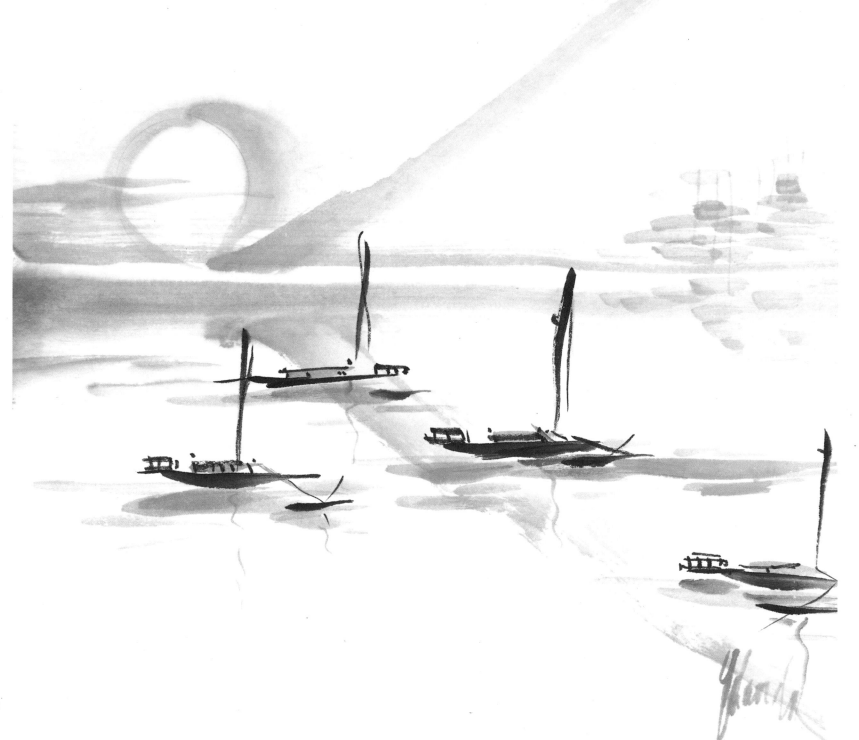

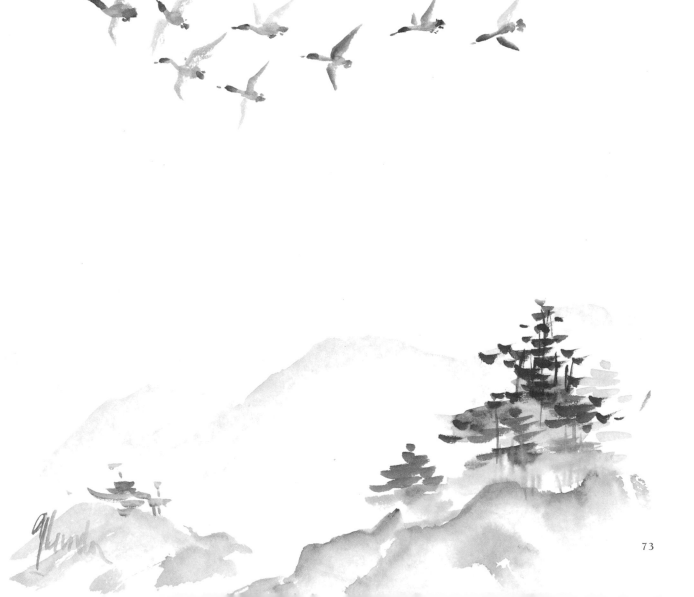

OPPOSITE: *Here a mood is created with two spare suggestions: the rising moon and the fishing fleet at anchor. The water is established by the reflection of Mt. Fuji, which is not fully in view but which has a solid presence.*

RIGHT: *Westerners are used to seeing a painting fill the picture area. However, here negative space dominates two-thirds of the picture plane, while tree-covered mountains establish a strong foreground. With the moon and migrating birds, the sky and even the season are understood.*

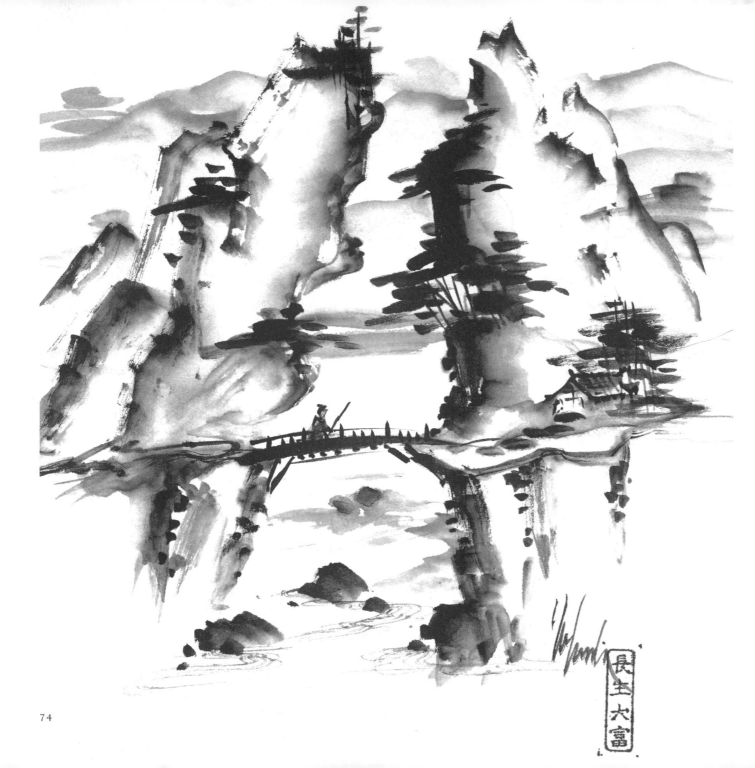

LEFT: *This painting area is completely filled but there is a space in the middle of the cliffs, which creates the impression that they were separated by a natural force. The bridge helps the dream traveler journey to the other side.*

OPPOSITE: *This composition leads the dream traveler artist on a journey from the path on the side of the cliff to view the scenery below.*

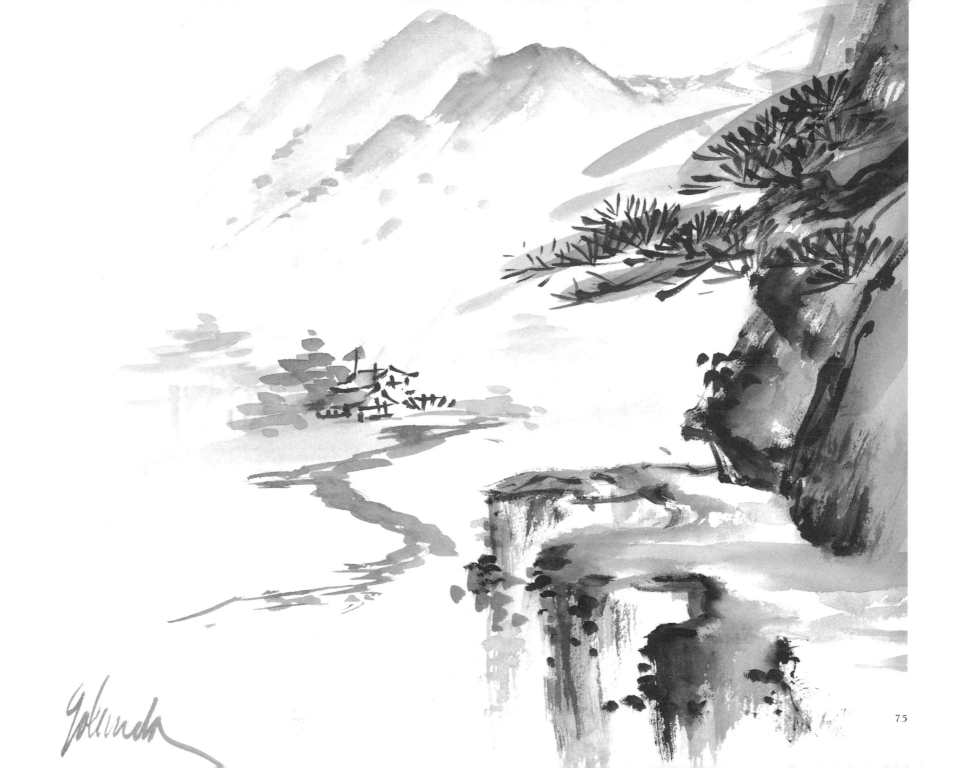

Vertical scrolls—which were a traditional format for sumi-e—were ideal for images such as this, with the "cloud touching mountain peaks." Here the peaks disappear into the mountain mist, with pagodas perched on top for the dream traveler to visit. Pagodas still exist on the mountain tops of China and Japan; it is for us to speculate about how they were built up there.

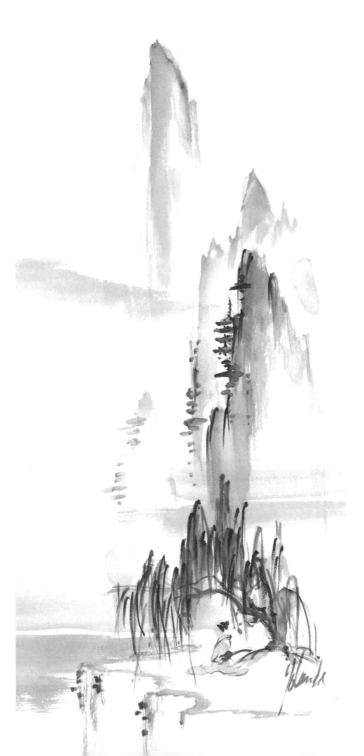

A triptych is a compositional method of leading the subject matter from one panel through a second and to a third. While the design on each panel must carry through to the next, each panel must also be a complete picture in itself. Triptychs provide artists with the flexibility of expanding compositions to fill the full wall area, softening a corner, or even wrapping around an entire room. The panels may be separate or they may be connected to form a screen, which may either be hung on a wall or set on the floor as a room divider.

In Japan, I enjoyed a memorable meal in a temporary dining area surrounded by a gold screen with maple leaves and birds painted on it. The maple leaves were stroked in perspective, so I felt as though I was in the middle of a maple tree forest—a true dream journey experience that has been with me for all these years!

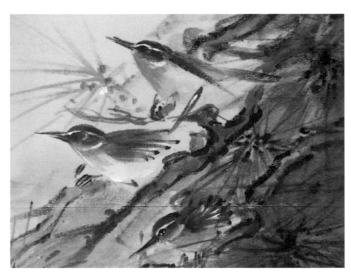

ABOVE: *Detail.* OPPOSITE: BAMBOO, PINE, AND BIRDS *From the collection of the artist.*

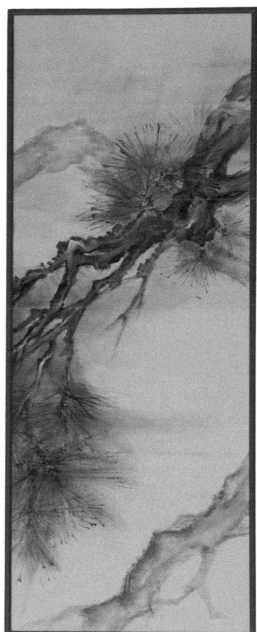

# Sumi-e in Color

Monochromatic painting can be unique and powerful—as it can both help an artist create a mood as well as help a viewer retain an image in his or her artistic memory. Typically, the atmosphere in Japan is foggy, which makes the landscape appear misty, so the shades of gray in sumi-e are often perfect for expressing this spectacular scenery. As a discipline, sumi-e places much importance on proper stroke language. Rich black and shades-of-gray washes combined with skillful, expressive strokes can take on color in the viewer's imagination. A significant sumi-e exercise is to paint a landscape in all seasons without the use of color. The language of the brush stroke and shading express the season's colors.

While the well-executed stroke is the main emphasis in the art of sumi-e, color can add a delightful dimension. Sometimes an almost pure monochromatic painting will be highlighted with a dash of color placed in an aesthetically pleasing position, as with Chang Dai-chien's painting *Cinnabar Lotus,* shown on page 8. However, as you add color to your repertoire, remember there is a sumi-e way to use it.

Your sumi-e brush can be prepared for color using a variety of techniques, including singleloading, doubleloading, and tripleloading. In all three cases the brush holds a wash; the difference comes in where or how much concentrated color the brush contains. Applying thick color on just the tip of the brush is considered singleloading. Placing color on either side of selected positions of the tip is called doubleloading. Placing two colors on the tip and then adding a third to the bottom of the brush (the part closest to the handle) becomes tripleloading. With this last method, each multilayered brush stroke creates variations of color. It also allows certain color details to be placed on planned positions on the brush with fairly accurate results.

In the end, color will delight the artist with its endless variations, pulling the artist into new color adventures.

RAINBOW SPRINGS IN SPRINGTIME, DUNNELLON, FLORIDA

*From the collection of the artist.*
*Shifting patches of turquoise and brilliant blue bring to mind the colors of Japanese woodblock prints.*

*Charge your brush with
a wash of violet for the
watery look. Place the
blue on the bottom of the
brush, near the handle.
Allow the wash to play
and blend and vanish into
the depths. If your colors
do not lighten fast enough
for the background strokes,
dab the brush lightly
against a cloth.*

83

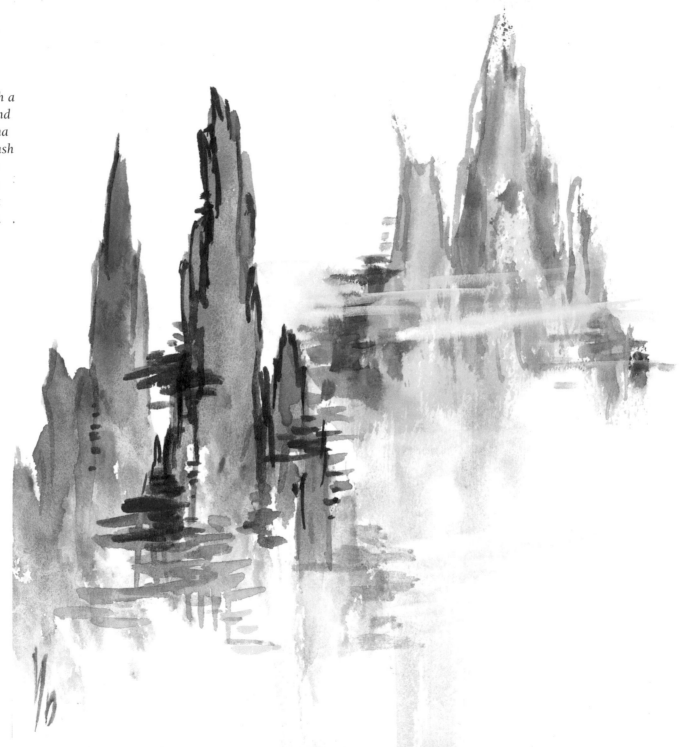

**TURQUOISE, GREEN, AND RAW SIENNA:**

*Charge your brush with a load of turquoise, a band of green, and raw sienna on the tip. Hold the brush vertically and push the stroke up with a strong motion. Remember that you are painting rocks. Let the colors resolve themselves and accent the shapes that appear.*

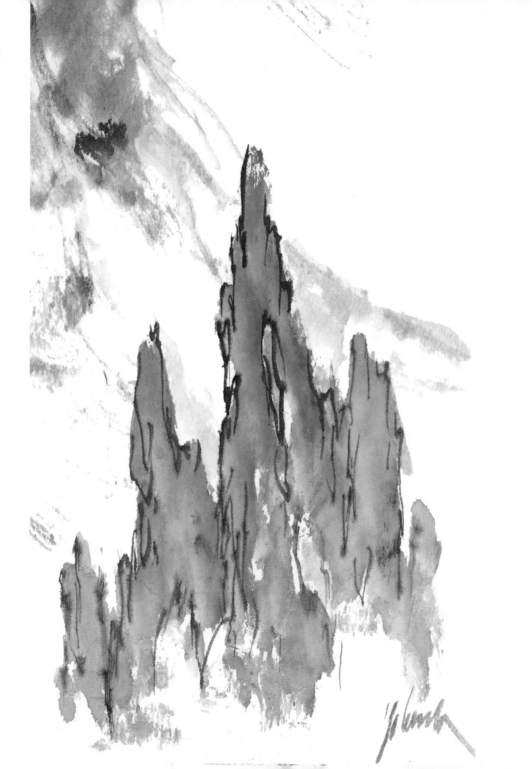

**TURQUOISE, GREEN, AND RAW SIENNA:**

*This rendering on traditional rice paper has its merits. This paper is very absorbent and sucks in the color quickly so it does not leave hard edges. It can be temperamental, but the results can be highly rewarding.*

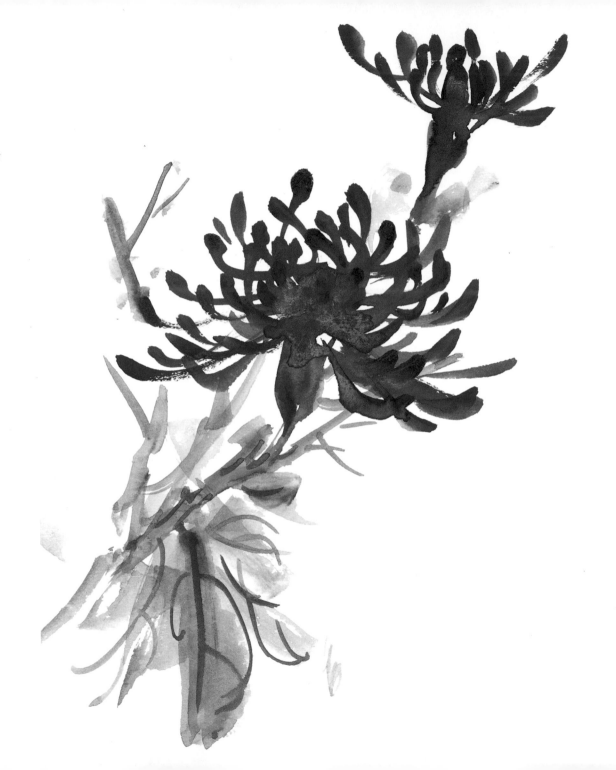

**VERMILION, PURPLE, AND LIGHT GREEN:**

*Load your brush with vermilion and tip it with purple. Paint the front petals first and then, once the color has lightened naturally from use, paint the back petals. Use a wash of these two colors with light green on the tip to paint the leaves.*

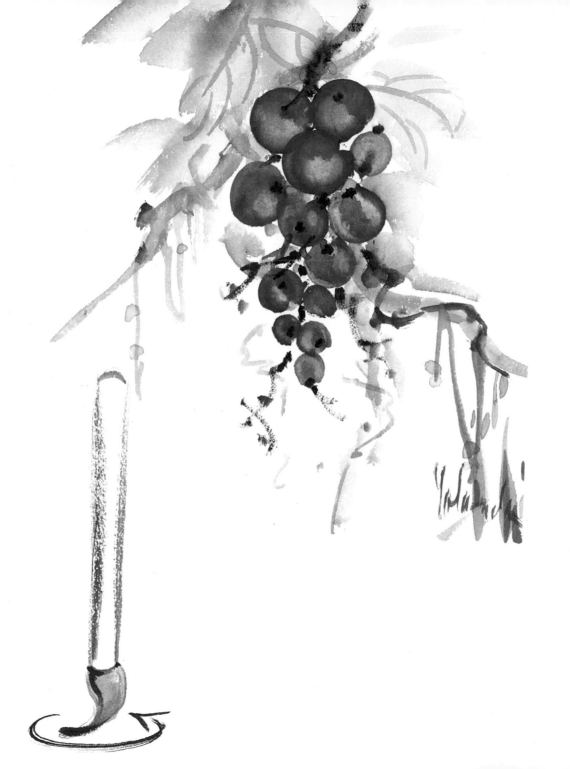

BLUE, PURPLE, AND
EITHER DARK BLUE
OR BLACK:

*Load your brush with blue
and purple and tip it with
either dark blue or black.
Revolve the brush in the
direction of the arrow for
the grapes' shape. Retip the
brush with dark blue or
black when needed. Once
you've finished painting the
grapes, the wash of color
that is left on your brush
can be used to make the
suggestive strokes for the
leaves and vines.*

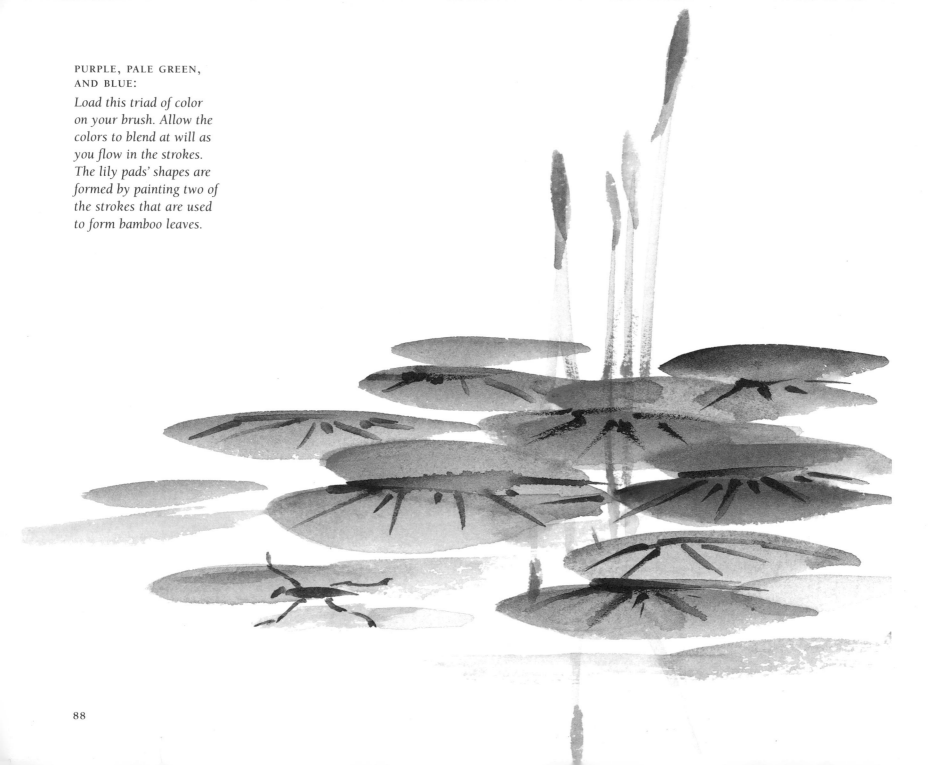

PURPLE, PALE GREEN,
AND BLUE:

*Load this triad of color
on your brush. Allow the
colors to blend at will as
you flow in the strokes.
The lily pads' shapes are
formed by painting two of
the strokes that are used
to form bamboo leaves.*

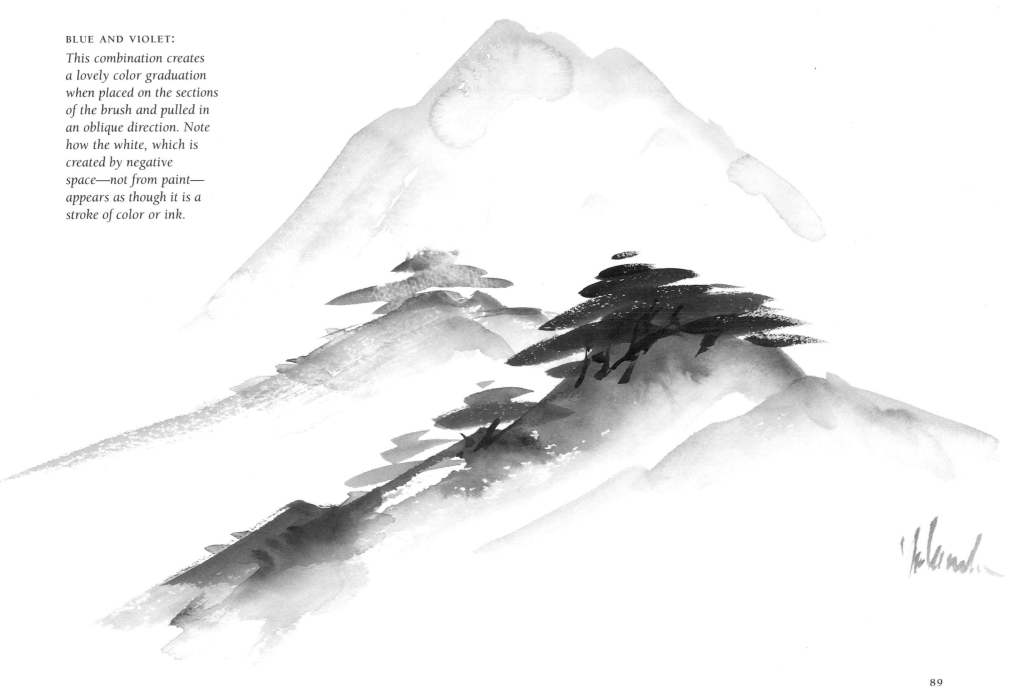

**BLUE AND VIOLET:**

*This combination creates a lovely color graduation when placed on the sections of the brush and pulled in an oblique direction. Note how the white, which is created by negative space—not from paint—appears as though it is a stroke of color or ink.*

89

## TARASHIKOMI

The *tarashikomi* technique (which loosely translates as "dripping onto a wet surface that mottles or ripples or surges") was probably developed in the early seventeenth century by the artist Tawaraya Sotatsu. It was perfect for creating the highly decorated gold screens and fans that were popular at that time.

*Tarashikomi* is a two-step method for creating exciting color effects. It is ideal for gold or other nonabsorbent surfaces. First, a wet wash of either ink or color is applied to the surface. The wash is allowed to dry partially, then drops of contrasting colors are dripped onto the wash. The mixing of the wet and partially dry colors creates a delicate merging, mottling, and artistic blending. The variations are truly endless and can be strong in appearance or very soft and mottled. However, this technique is "a one-way street" and you have to accept what is presented to you.

This technique is generally used to depict natural subjects, such as cherry or plum tree branches, leaves, rocks, mountains, or water. It can also suggest lichen, texture, or just exciting coloration. Many museums have examples of fans or screens that have been decorated using the *tarashikomi* technique. There are several wonderful examples in the Freer-Sackler Galleries in Washington, D.C.

IRIS
*From the collection of the artist.*

*Ted Mayhall,* A DANCE OF BEAUTY.
*From the collection of the artist.*

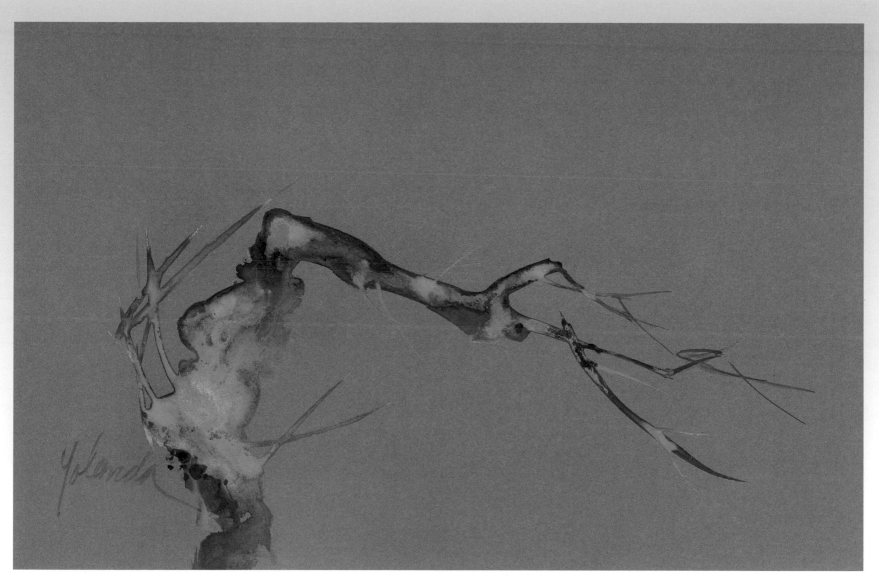

A PRUNUS BRANCH AWAITING SPRING

*From the collection of the artist.*

# Planning the Journey

As you begin to plan your sumi-e dream journey, you will become aware of the importance of two preliminary exercises—sketching and structuring your sumi-e sketches.

Sketching can be done in the studio, with a selection of images contributing to the initial inspiration. However, my favorite place to sketch is outdoors, in nature. When you set out for "on-the-spot" sketching, keep your equipment simple. A sumi-e brush, a small container for liquid sumi, and a sketch pad are all you need.

The very act of sketching builds other skills. Consistent practice releases inhibitions, which not only encourages your strokes to be more free but also may lead you to discover a new style that reflects your personality. Sketching also will help you learn how to observe your surroundings rapidly with freedom of motion and mind. Plus it can be fun, for people are always fascinated with the magic of art. One of my most endearing memories was sketching in a fishing village in Japan one bright morning. The ladies that were watching me remarked, "How interesting it is to see a foreigner painting a sumi-e." What a gem!

After sketching outdoors, bring your sketches back to your studio and compose them so that they gel in a single flow of energy. Try to evoke all the freshness and energy from your outing, recalling the mood of the moments. Writing comments next to your sketches while you're working may help stimulate your memories once you're back in your studio. Rework your sketches, arranging them in every possible way. You may even want to deliberately create "bad" compositions that violate all the rules. Trying different structuring techniques will help pave the way to your dream journey paintings.

All these preparations—the sketching, structuring, and experimenting—all fall into play for your final work. This is hard and necessary work, but don't allow it to rob you of your pleasure for sumi-e. Give yourself some play time and do a little dreaming, for one of the most important elements of sumi-e is the spiritual side. You should take time to dream about your painting and lose yourself in the mental preparations. This will help you express the spirit of your dream journey painting.

# Practicing Sumi-e Sketching

In addition to being a useful tool for creating finished paintings, your sumi-e brush is a marvelous instrument for on-the-spot sketching. On a lovely day, when being outdoors seems important to refresh your artistic spirit, sumi-e sketching can provide a treasure trove of inspiration. Sketching also helps to simplify drawing problems, stimulate creativity, and in general promote a feeling of calm. I look back on sketches I made many years ago in Japan and am able to recall those days with joy. However, if you—like many of the ancient dream journey painters—are unable to leave your studio to paint on location, a "swipe file" of inspiring images is an absolute necessity for preparing for your dream journey.

Many serious artists stockpile a swipe file. These images—which may be culled from magazines, brochures, or even television—bring ideas to your studio from all over the world. Beautiful photographs, exquisite layouts, and striking designs can all provide inspiration. Personally, I depend on *National Geographic, Archeology,* and numerous nature magazines. I am also fortunate in that my dear friend Tomoko Sargeant passes on to me *Fugin Gaho (Ladies Illustrated),* a superb magazine from Japan. The articles on art, calligraphy, ceramics and porcelains, flower arranging, and Japanese gardens provide a constant source of ideas. I also like to study the *New Yorker* for the wonderful monochromatic brushwork in their famous cartoons. Gathering, organizing, and categorizing your swipe file is essential to prevent loss of time from fruitless searching.

An abundance of working material is available to you for inspiration and knowledge, for study of the environment, and for broadening your artistic horizons. However, whenever you are reviewing an alternative source, remember your sumi-e language and resist the temptation to copy. The aim of the sumi-e painter is to draw upon his or her artistic spirit and personality in order to express, rather than show, a certain image or feeling.

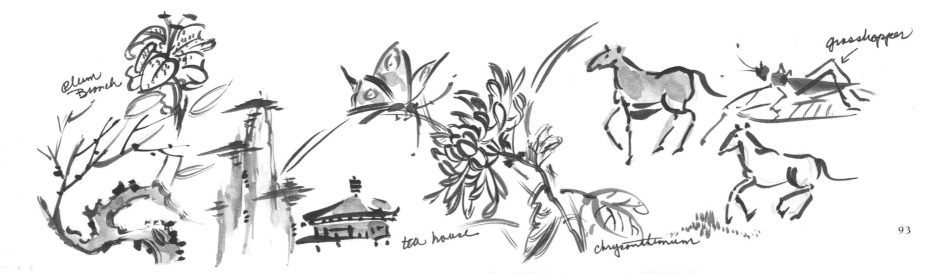

Plum Branch

grasshopper

tea house

chrysanthemum

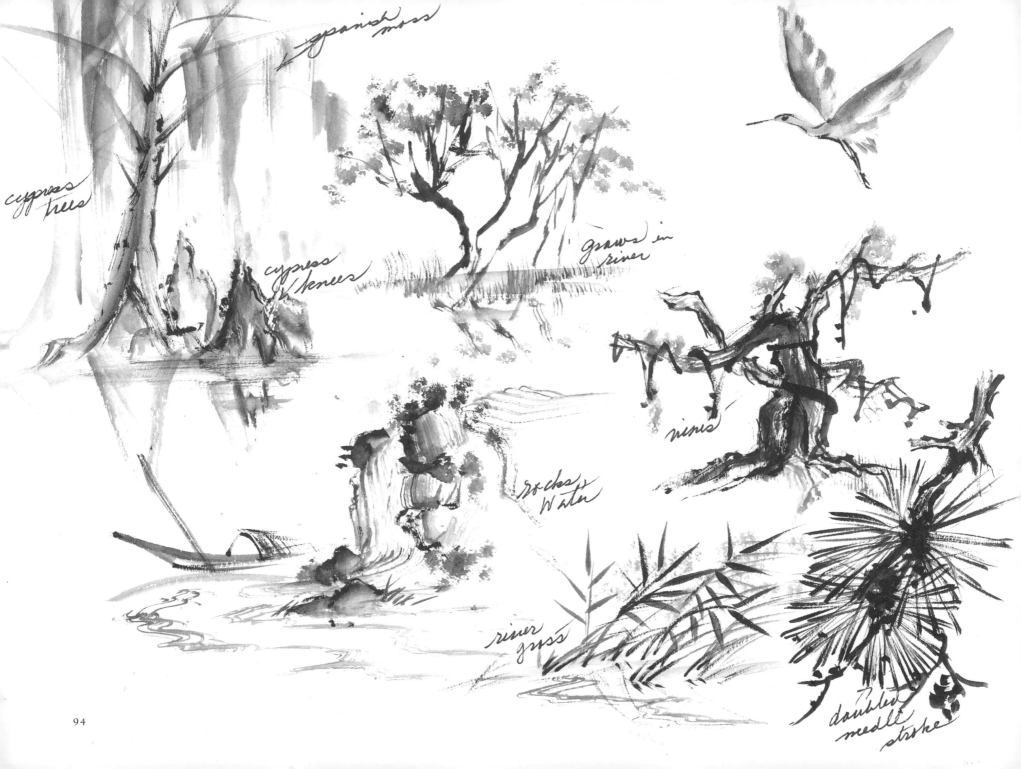

spanish moss

cypress trees

cypress knees

grass in river

rocks + water

vines

river grass

doubled needle stroke

94

peaks, bridge, boat

gnarled pine / stylized needles

palm in sumi-e

needles curved up, down & across

ground bamboo

camellia

95

# Structuring Your Sumi-e Sketches

Structuring your sumi-e sketches is the next step toward creating your sumi-e dream journey paintings. Sometimes the structuring process involves a time-honored device called "thumbnail sketches," or miniature sketches. This simply means that you are organizing your sumi-e sketches into small but complete compositions that can be easily compared to each other. Making thumbnail sketches is a good discipline that builds the habit of exploring, comparing, and working in complete compositions.

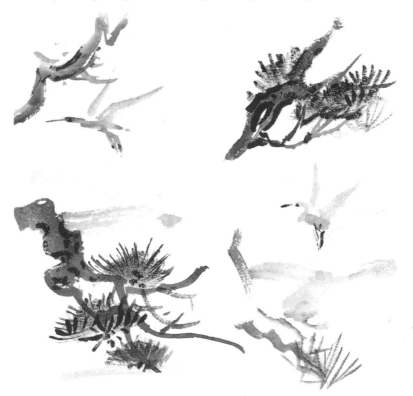

For a prolific artist like Hokusai, dedication to art consumed a large part of his daily routine for most of his lifetime. Throughout the years he seemed to record everything he imagined and observed. His sketchbooks are often referred to as his "miscellaneous studies" and they are valued as much as his finished art. His art expresses humor, emotion, and descriptions of civilizations past. When I study Hokusai's spontaneous sketches I feel as if I am savoring the moment with him.

Unless you are a full-time artist, it may be not be possible to dedicate a large part of your day to art. However, fruitful opportunities arise all the time—even in unlikely locations. In my art school days, my daily lesson consisted of sketching people and their surroundings on my subway trips back and forth to school. You may find yourself watching people while you are at outdoor shows, concerts, and the like. Keep simple art materials handy and sketch while you are standing in the checkout line, cooling your heels in the doctor's office, or wherever else you may be inspired.

It doesn't matter if your sketches are incomplete, for they simply need to record the memory of the moment. Once you're back in your studio, you can restructure your rough sketches into thumbnail sketches, tweaking them here and there, creating variations upon a theme, so that you create what you feel is the best composition. After you've finished your studies, make sure to file and store both your rough and your thumbnail sketches—for they will become the germinating seeds for future projects.

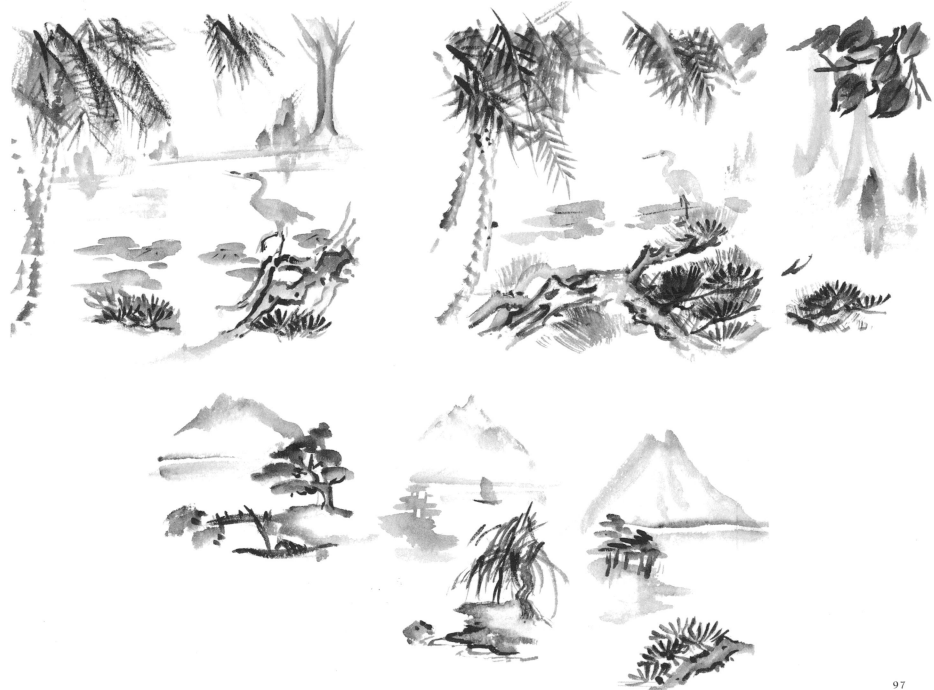

# Exploring New Techniques

Sometimes I like to experiment with techniques that fall in the splash ink, broken ink, or drop ink style. These three techniques naturally lead the student from the traditional style into the impressionistic stream of painting. Because the extraordinarily versatile sumi-e brush is capable of producing a multitude of effects with a single stroke, when the artist moves it in a spontaneous explosion of strokes, the brush is free to improvise. Likewise, using these nontraditional techniques, you are free to improvise.

*By pressing a natural (rather than a silk) sponge that had been moistened with water and multiloaded with diverse colors onto my paper, I created the basic form for this tree. When working with this method, keep your attention on the basic contour of the image you want to create.*

Here is an exercise I have created for my students to expand the boundaries of their imagination. I have them place three layers of rice paper on top of one another and then apply paint or ink (either by pouring or by stroking) to the top layer. The layering allows the color to seep through, which creates a myriad of abstract images, each page more subtle than the previous one. I have found that these forms—which may initially seem like blots—often present inspiring ideas. For instance, when confronted with a blur or a blush of paint, you might find that, with a few deft linear strokes, you are able to help a steep mountain materialize. Sometimes what emerges on the reverse side of a piece of paper is even more exciting than what is on the so-called "right" side. Also, for this way of creating, I often encourage students to try changing their painting hand—either from the right to the left or vice versa. Sometimes a totally new style emerges.

Try other innovative methods, too. For instance, alum that is sprinkled on a wash and then brushed away once the paint has dried creates the effect of lovely snowflakes. Splattering white paint from a toothbrush onto a wet painting can create marvelous effects. Likewise, unusual textures can be created by sprinkling salt onto a wet surface and then allowing it to dissolve. Crunching up rice paper and saturating it in tea creates fascinating textures and wonderful images can be created by loading a natural sponge with various colors and then pressing it artistically to your painting. You can experiment with these methods as well as discover new methods, but, in my opinion, nothing can replace the beautiful sumi-e stroke!

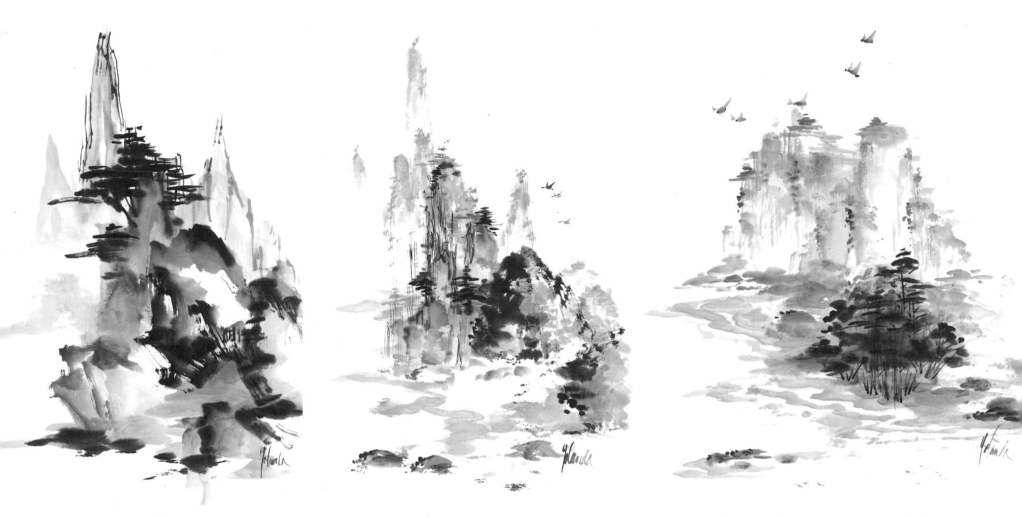

These three images were inspired by the abstract blots that were created when the three pieces of paper were placed on top of one another and a loaded brush was moved around the top sheet in an expressive stroke. Note, for instance, how the bold, green mountain (which is prominent at the top of the left-hand image) becomes more ethereal in the middle image and then virtually nonexistent in the final image.

# Beginning the Dream Journey

You are now on your way to dream journey painting, so keep in mind that it is not only the subject that gives life to art, it is the spirit that is within the artist's genius. This spirit is born when the artist personalizes it through skill and style. The artist is a conduit through which a stream of spiritual inspiration flows—from its divine origin through the artist to its resting place on the picture plane.

At this point you have memorized your sumi-e vocabulary, the brush strokes. Color, composition, and creativity are less of a mystery. And you and your brush have mutual respect—not only are you able to understand your brush's offerings, but you recognize your creative accidents.

It is time to gather your materials around you for ideas, reference, and inspiration. Your imagination and emotions may need to be stirred. Memories, fantasies, colors, seasons, poetry, music, photography, and a particular environment can all help accomplish this. However, you may still be plagued by writer's block: "I have all the proper materials and skills, but what shall I paint?"

My teachers often persuaded me to start with that which I loved most, such as twisted pines and birds; but they also taught me that if my brush strayed from the original subject, I should move with it as the opportunity presented itself. An artist is constantly being influenced and every painting experience brings growth along with it. When an artist wants to create beauty, he or she must become subservient to creativity—to accept that which flows to one from its occult origin. Creativity will not respond to command; it is the freest of all of the forces of the universe. Thus every painting, whether it is the first or the last, is an entity unto itself. The *act* of painting *is* the painting.

It is almost impossible to describe in words a flash of inspiration and genius for sumi-e art. Human beings are slaves to creativity, rather than the other way around. Creativity will not respond to command; it must be gently encouraged. Therefore, the painting must be in your own words—a sumi-e dream journey.

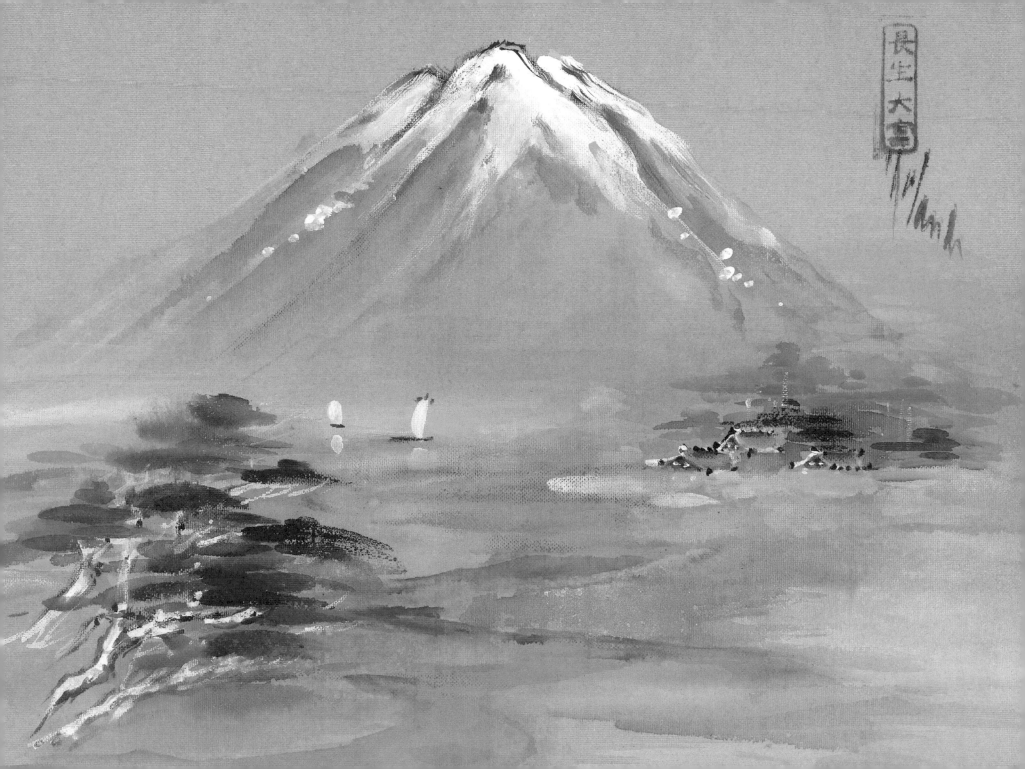

# Dreaming

to Dream

In moments when I am painting and concentrating intensely, I sometimes experience a flash of inspiration and I can feel Hokusai's artistic presence come to life through the strokes of my brush. Once again, the spirit of this artist works with me. His presence is almost palpable. His love of this art communicates itself to me.

How fortunate we sumi-e painters are to be the means by which this ancient transcendental art can be perpetuated and dwell forever in the hearts of artists. Perhaps each sumi-e dream journey should start with a prayer: "You beautiful thing. I have the honor to paint you into existence."

Have a good dream journey!

RIGHT: *Ted Mayhall,* TO DREAM (YUME)
*From the collection of the artist.*

OPPOSITE: LIVE OAK (*Detail*)
*The Withlacoochee River lifts its veil of morning mist.*
*From the collection of Mr. and Mrs. Perry Nichols.*

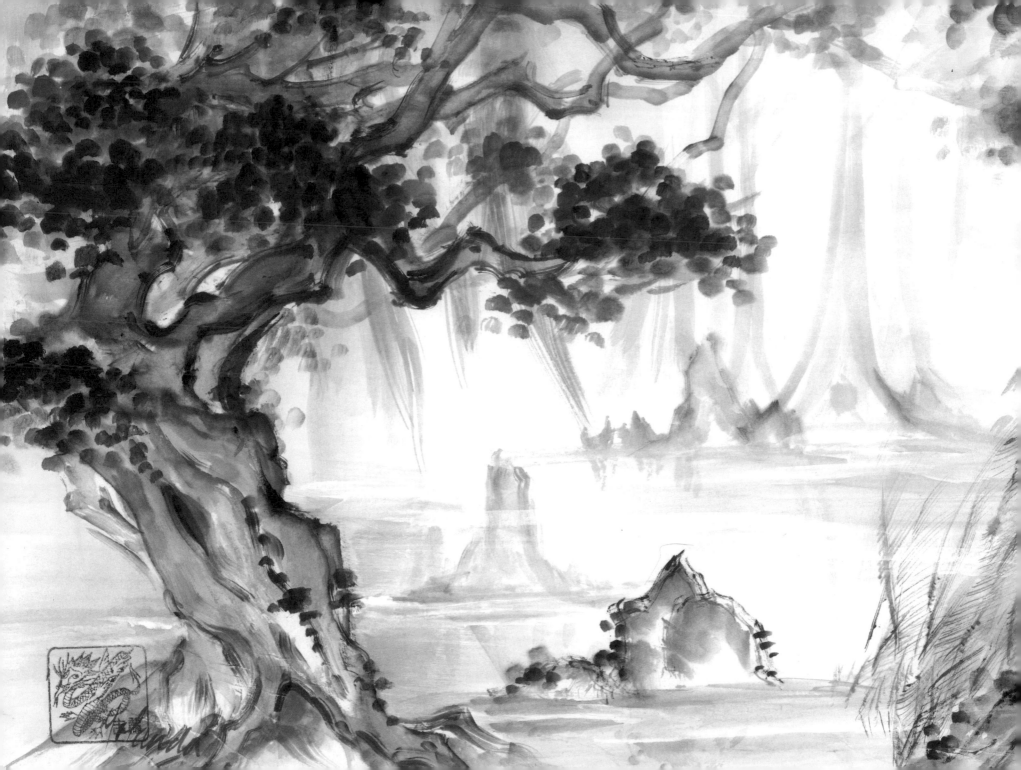

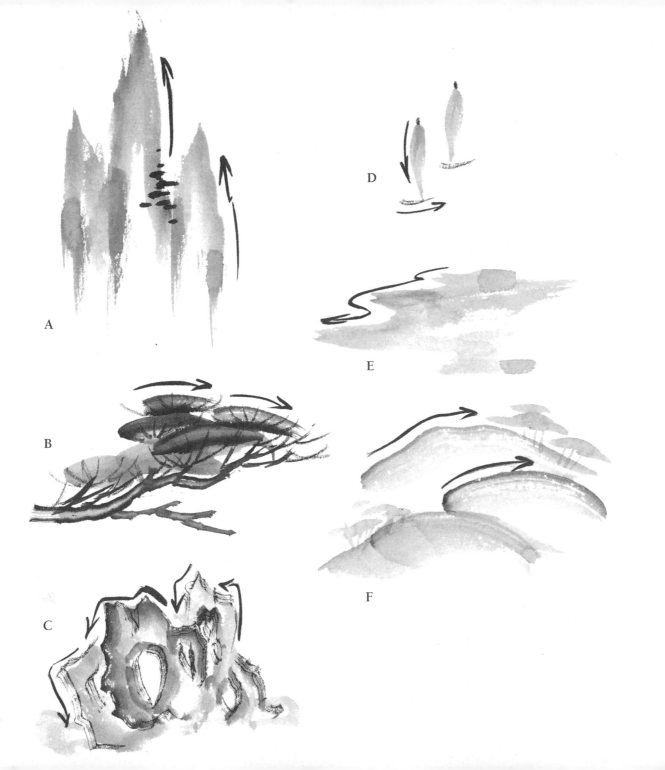

A With a shaded stroke, push your brush up into the shape of the mountain.

B For the foliage, brush in soft, curved strokes arranged in a layered fashion.

C For the rocks, apply a dry wash to your brush and then move it following the arrows with a strong motion.

D A single soft Wild Orchid stroke suggests the billowing sail on a boat in the distance.

E Lay your brush almost horizontal to the paper and push it to create the desired landform shapes.

F For the distant hills, load your brush with a light wash and tip it with a darker tone, then flow in large, soft curved strokes.

OPPOSITE: A DREAM JOURNEY TO ANCIENT CHINA

*My brush and I travel back in time to ancient China. At dusk the mists envelope the houses along the river, as the rocks and pine tree, eternally intertwined, stand guard.*

*From the collection of Peter and Marie Zacharko.*

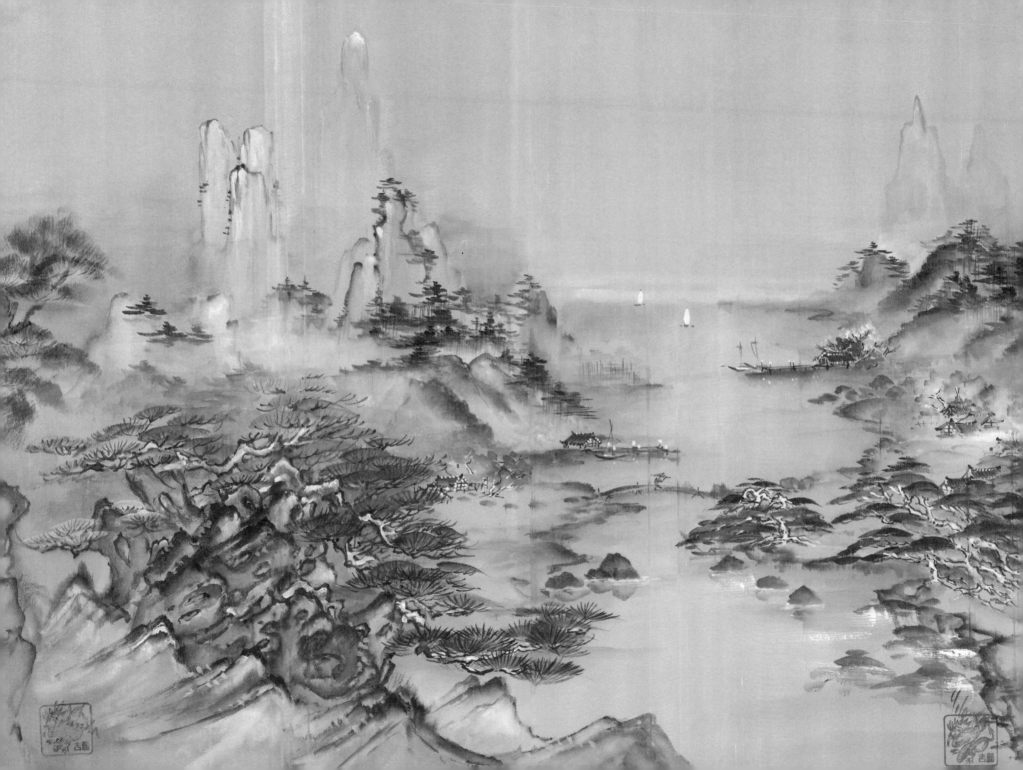

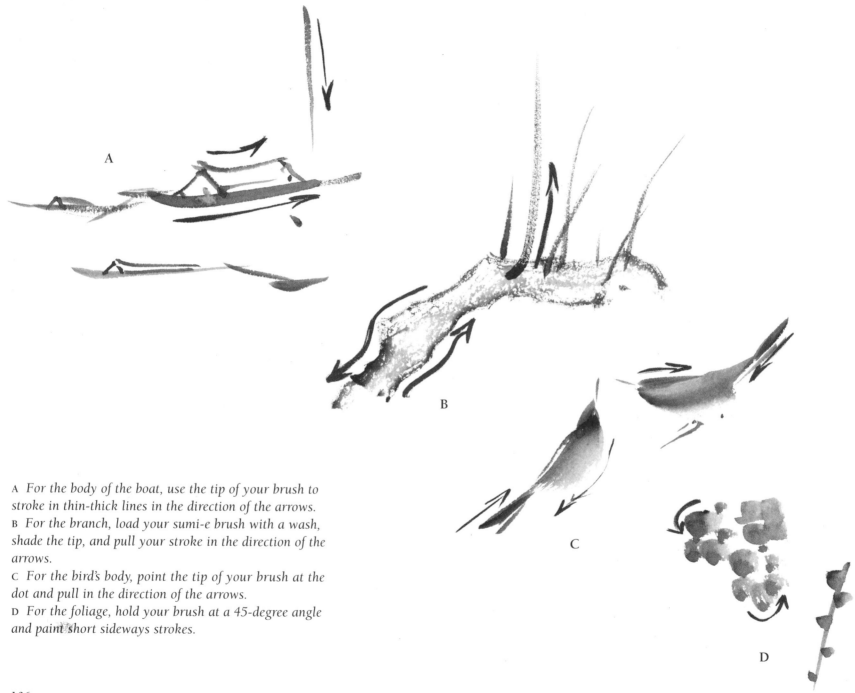

A For the body of the boat, use the tip of your brush to stroke in thin-thick lines in the direction of the arrows.
B For the branch, load your sumi-e brush with a wash, shade the tip, and pull your stroke in the direction of the arrows.
C For the bird's body, point the tip of your brush at the dot and pull in the direction of the arrows.
D For the foliage, hold your brush at a 45-degree angle and paint short sideways strokes.

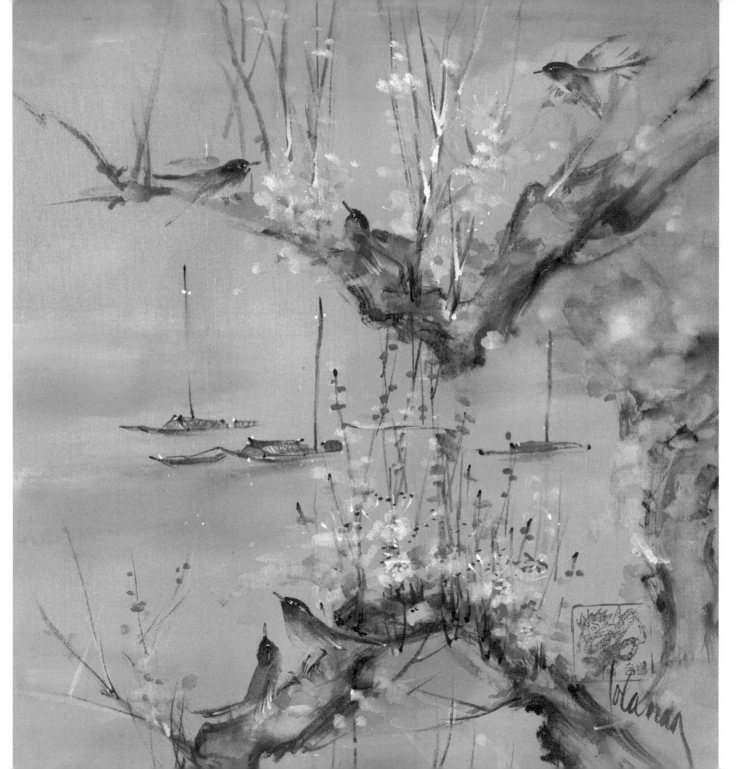

*Birds are singing as morn-
ing lifts her misty veil.
From the collection of Mr.
and Mrs. John Sargent.*

107

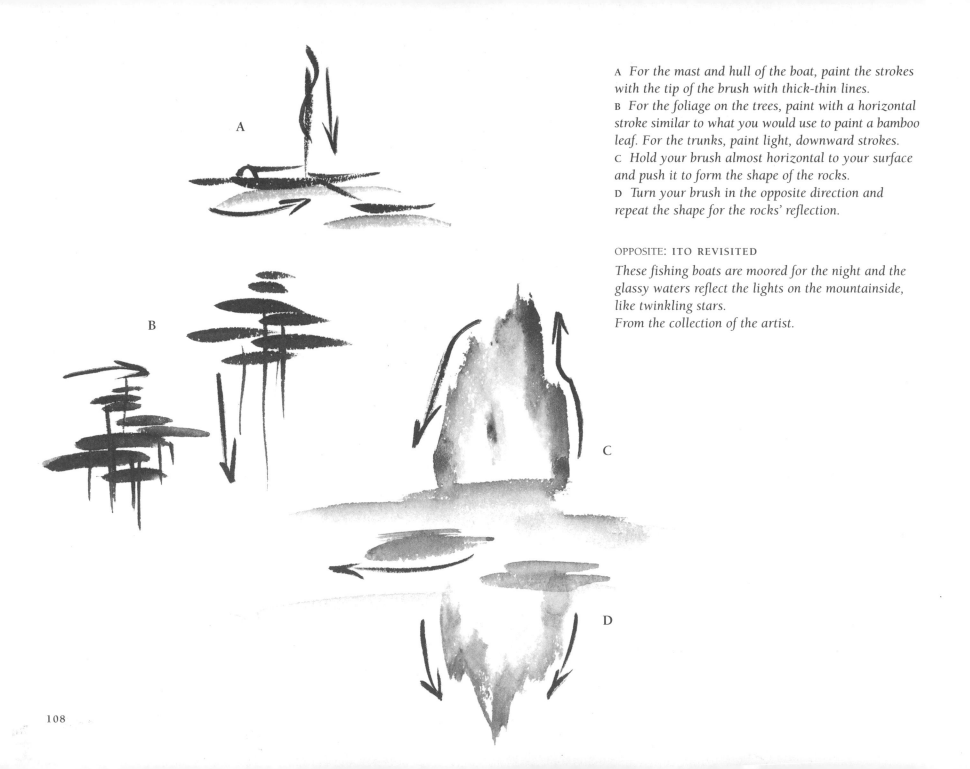

A For the mast and hull of the boat, paint the strokes with the tip of the brush with thick-thin lines.

B For the foliage on the trees, paint with a horizontal stroke similar to what you would use to paint a bamboo leaf. For the trunks, paint light, downward strokes.

C Hold your brush almost horizontal to your surface and push it to form the shape of the rocks.

D Turn your brush in the opposite direction and repeat the shape for the rocks' reflection.

OPPOSITE: ITO REVISITED

These fishing boats are moored for the night and the glassy waters reflect the lights on the mountainside, like twinkling stars.

From the collection of the artist.

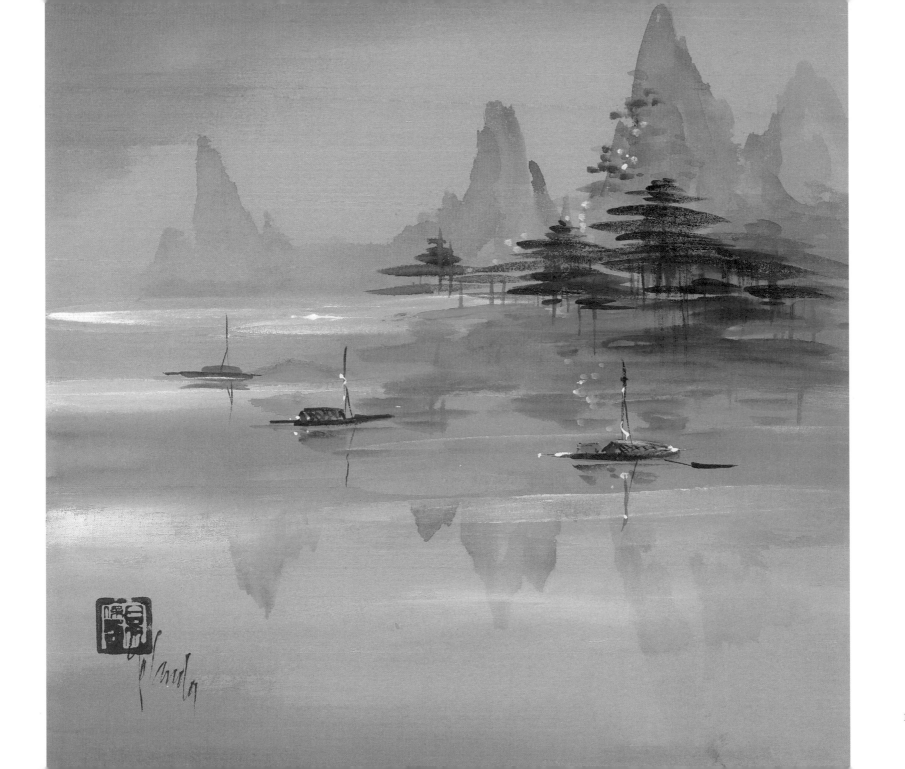

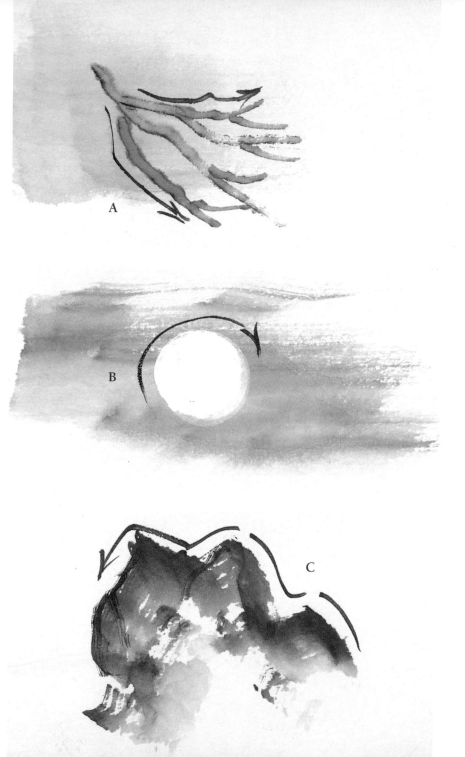

A *For the branch, load the brush with a wash and tip it with thick paint. Slightly dampen your surface. Hold the brush at about a 45-degree angle and follow the direction of the arrow.*

B *For the moon, load the brush with white paint and hold the brush vertically. Rotate it in the direction of the arrow.*

C *For the rock, load the brush with a wash, then tip it with thick paint. Lay the brush horizontal to the surface and push up into the shape of the rock following the direction of the arrow.*

OPPOSITE: **TYPHOON TIME**

*The restless waters herald the approach of a typhoon. From the collection of the artist.*

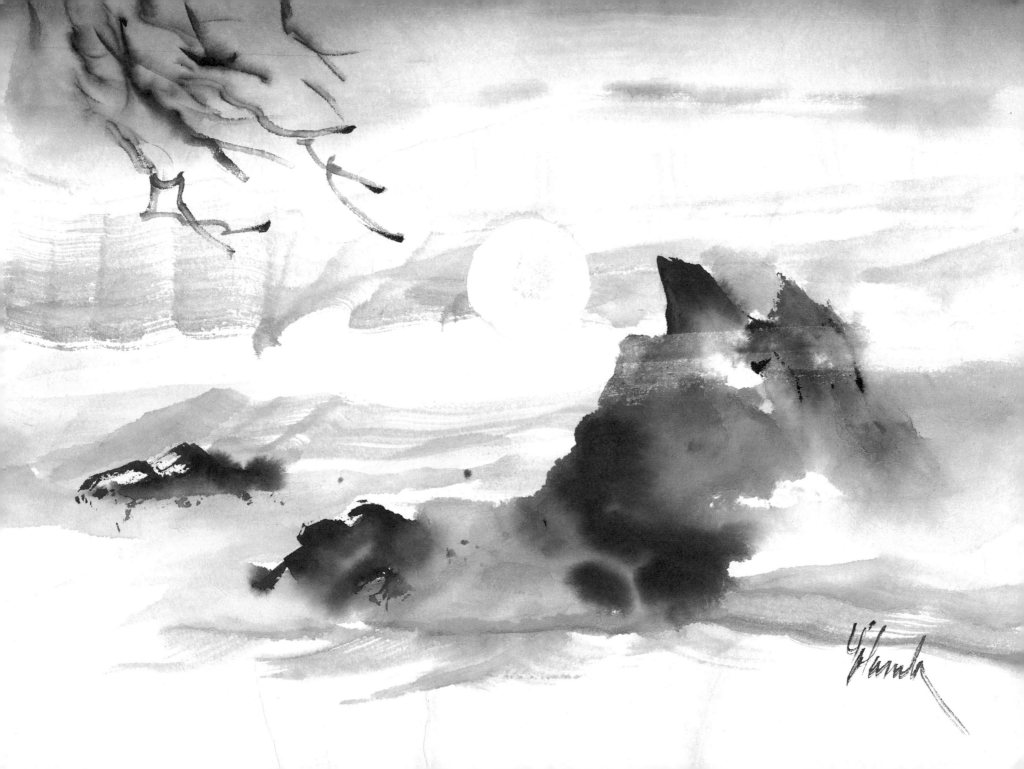

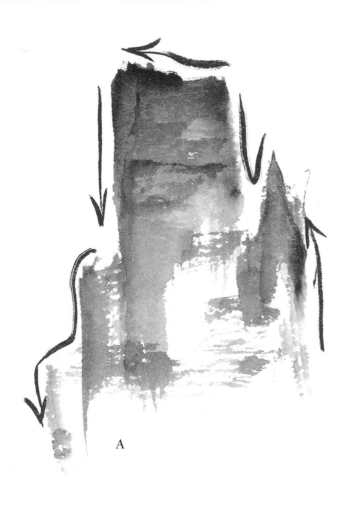

A  Paint the butte-like land formation with a brush that is loaded with a wash and tipped with a darker shade. Push the brush up into its shape and follow the direction of the arrows.

B  With a splayed brush, pull the stroke down to form the body of the cactus. Add the cactus arms, following the arrows.

C  To make the mesa-like land formation, load your brush with a wash, tip it with a darker shade, and then follow the direction of the arrows.

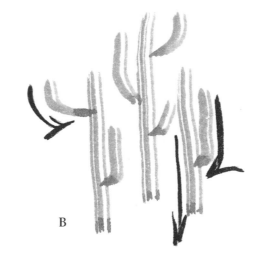

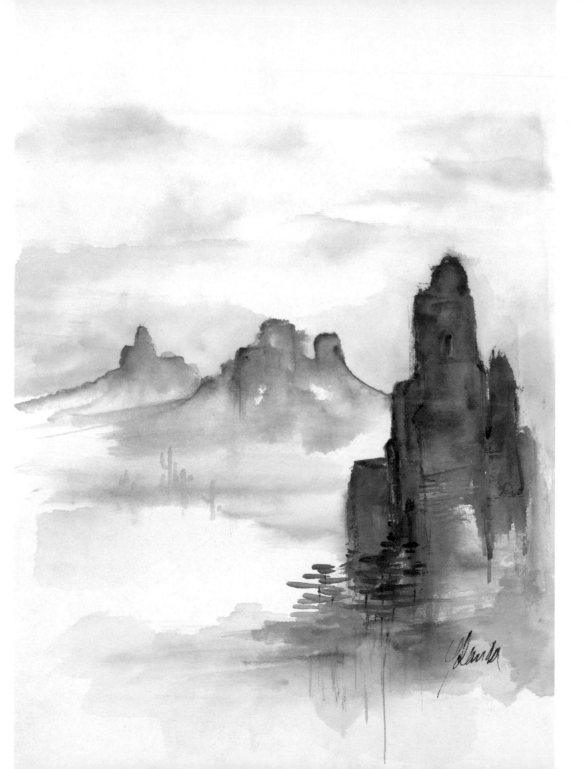

**THE AMERICAN WEST DREAM JOURNEY**

*A desert twilight. Sumi-e strokes are even perfect for the scenery of the American West and can be used to paint memories of a vacation of a lifetime.*
*From the collection of the artist.*

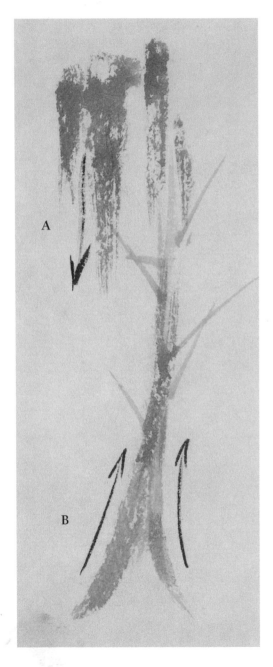

A *To paint the Spanish moss, hold your brush horizontal to the surface and brush down lightly following the direction of the arrows.*

B *For the cypress trees, hold your brush upright and pull upward.*

C *With an upright brush, stroke in the direction of the arrows to create the heron.*

D *Hold your brush almost horizontal to the paper and stroke in the shape of the cypress knees, following the arrows.*

E *For the palm bush leaves, hold your brush upright and use the tip to stroke in the direction of the arrows.*

OPPOSITE: **IMPRESSIONS OF FLORIDA'S WITHLACOOCHEE RIVER**

*A lone heron stands sentinel. Again, sumi-e strokes work perfectly for Florida's cypress trees, herons, and palm bushes—especially when blue rice paper is available. From the collection of the artist.*

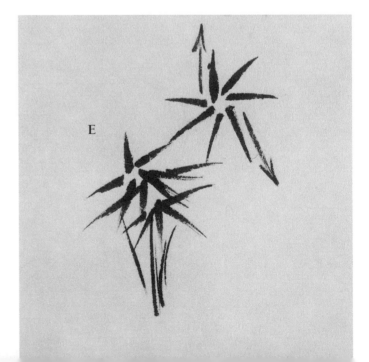

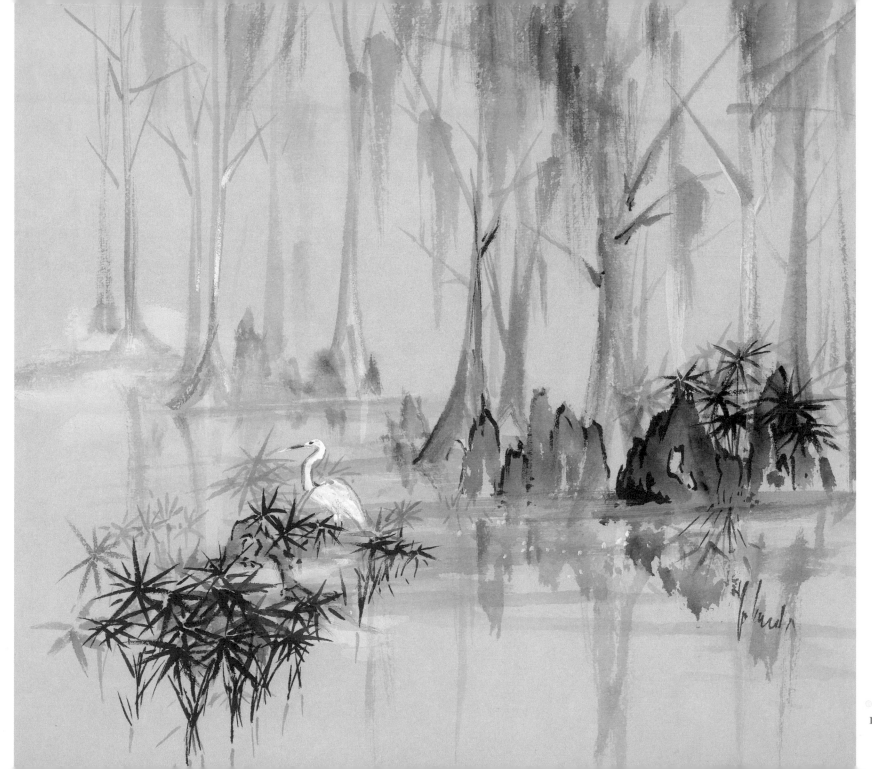

115

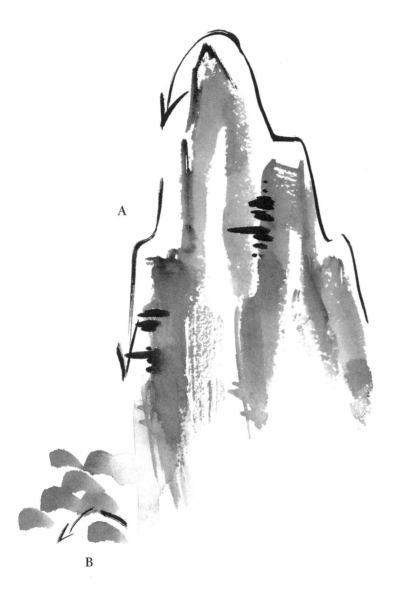

A To paint the tall distant mountains, load your brush with a light wash, hold it horizontal to the surface, and push it upward into the shape of the mountain, following the direction of the arrows.

B For the foliage, push the brush slightly up and then down in a curved motion.

C For the tops of the trees, hold the brush straight and brush the stroke in the direction of the arrow. This stroke originates from the stroke used to paint the bamboo leaf.

D Drag just the tip of the brush in a downward motion for the trunks.

E The stroke that is used to create the lily pads is the same stroke as is used for the foliage of the trees—but shorter and slightly curved. Follow the directions of the arrows.

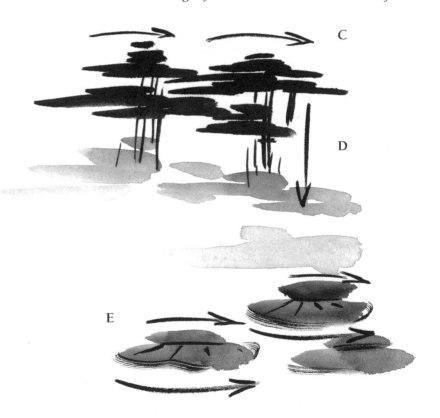

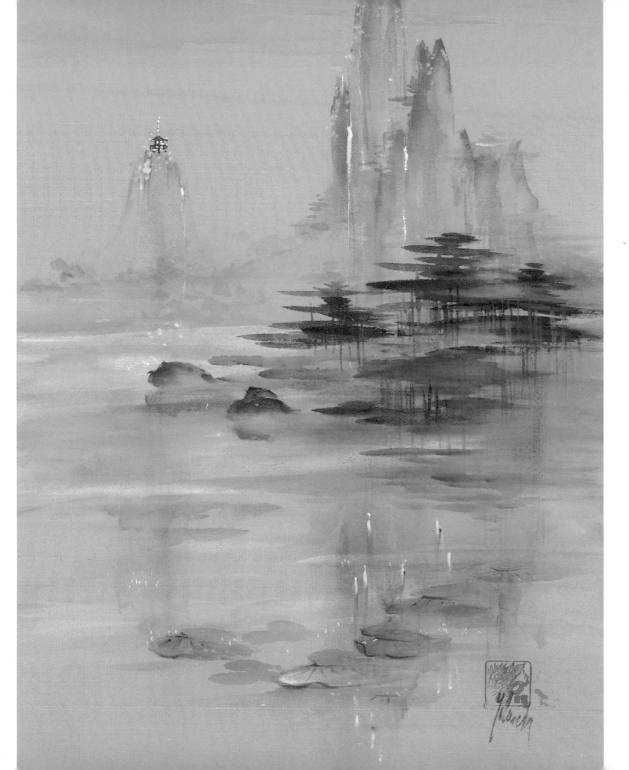

**A SUMI-E DREAM JOURNEY**

*My journey has materialized and I can stop and marvel at it. The scene I have painted exists somewhere, perhaps in a realm I can only reach in my dreams.*
*From the collection of Wendy J. Mayhall.*

# Enhancing Your Dream Paintings

Because Sino-Japanese characters are pictograms (drawn pictures) rather than alphabetic letters, sumi-e and *shodo* (calligraphy) go hand in hand in Asian cultures. They are also similar in that they are both produced with brush and ink. Often a person who is a superior calligrapher is also a great artist, and the art forms of poetry, calligraphy, and painting can beautifully complement each other.

Ted and I will not delve too deeply into *shodo* in this book—both because it is a separate and quite intricate art and because a working knowledge of the Japanese language is desirable in order to become a *shoka* (calligrapher). However, we want you to be aware of the art of *shodo* and its influence on sumi-e.

*Ted Mayhall,* THE BEAUTIFUL, THE TRUE, THE GOOD
*From the collection of the artist.*

There are either five or six styles of *shodo*, depending on how we define them. The two principal styles are *kaisho* (square or regular style) and *sosho* (grass speedstyle). All of the other styles are used, of course, but *kaisho* and *sosho* are the ones most favored by Asian calligraphers.

The brush movements used to create sumi-e and *shodo* are very similar. In addition, the same brushes—*fude* and *hake*—are used in both arts and expert brush control is important to both the *shoka* as well as the sumi-e ka. *Shodo* pieces appear mostly as poems, proverbs, and picture captions. They are eminently collectible, but we think that it's more fun to create them than to collect them. Those of you who are Western-style calligraphers might caption your dream journey paintings with calligraphy in your own language.

The character "aoi," which means "blue," in both the kaisho (*square*) and sosho (*grass*) styles.

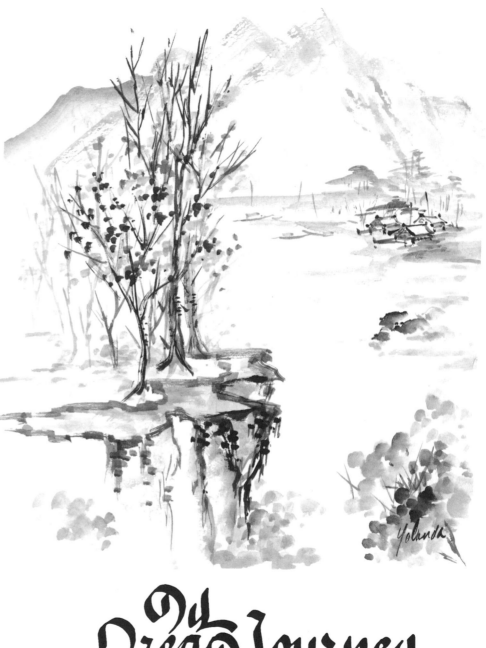

My Dream Journey

119

Sumi-e and *shodo* brush strokes have several important things in common. Indeed, in some cases they are the same strokes. As with sumi-e strokes, *shodo* strokes should be skilled and at the same time spontaneous; they are the result of Zen concentration, the subordination of the conscious to the subconscious, wherein the psyche, rather than the intellect, actually does the painting. To be sure, there are many things that seem, when superficially regarded, to be mechanical in nature. To the untrained eye, *shodo* may appear to be one of these things. However, language, writing style, stroke order, brush techniques—all contribute to the perfection of *shodo*.

Most Asian artists depend upon the pervasive utility of Zen. What most think of as a meditative religious discipline is actually a way to use the entire being to create beautiful things and movements. As do the calligrapher and ink-painter, the dancer, singer, and even the *taiko* drummer, store in their muscles the raw materials of their art.

Many, if not all, Japanese sumi-e ka have also been *shoka*, both titling and adding poems to their painting that matched and complemented the pictorial content. For those who do not intend to make a serious study of the Japanese language, it is not at all difficult to learn enough about a few ideograms and *kana* (syllabic symbols) to use them to form simple titles for your art.

There are six styles of each of the 42,000 Sino-Japanese ideograms (the Japanese use only 1,200 of them). Taking the character that means "eternal" as an example, they are:

*Regular style, which is used most often*

*Grass speedstyle*

*Cursive style*

*Formal style*

*Ancient seal style*

*Typographic style*

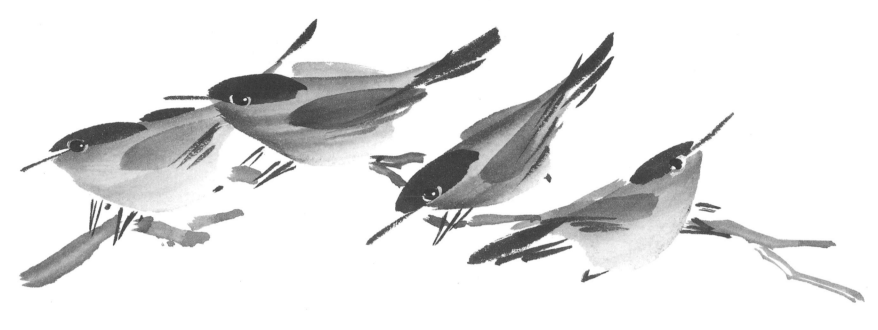

All six of these styles have specific uses, but the *gyosho* (cursive style) and *sosho* (grass speedstyle) are more flexible than the others, largely in that they permit some variation in space and balance. We will, therefore, use *gyosho* for our purpose, the titling of a painting.

The painting we have chosen is the one above, which has a lot of Yo birds in it.

We'll call it simply *Yo Birds,* making it possible to use the *kana* symbol "Yo" and the ideogram "Tori," meaning "bird." The title of the picture becomes *Yo Tori.*

The *hiragana* "Yo" is written with two strokes, which are placed together.

Practice them until the ideogram looks right to you. Remember, you are the judge. Your opinion is final. If you like it, it's right. If you don't like it, do it until you do!

*The* hiragana *"Yo" is written with two strokes, which are placed together.*

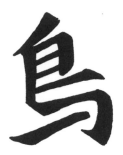

Now we'll try the ideogram "birds." (Actually, since for the most part plural forms are not necessary in Japanese, we will use the ideogram for "bird.") Let's decide to use the cursive style for our title, which our *shodo jikan* (calligraphic dictionary) tells us is the image at left. The stroke order appears below. Practice it until you like it.

Now practice the yo and bird symbols together, written vertically from top to bottom. They should look like the image below right. Sino-Japanese characters can be written vertically from top to bottom, horizontally from left to right, or horizontally from right to left. The most common orientation is vertical.

We now pick an area for our title. In this case, the best place is to the left of the painting. You have practiced the title until you can almost paint it automatically, Zen style. Paint it in the prescribed area. Now your painting should look like the image opposite.

Beautiful, isn't it?

よ
鳥

## A CHILD'S ADVENTURE WITH SUMI-E

I have found that children fully enjoy the art of sumi-e. When I introduced sumi-e to a class of third-grade students, they easily learned all the basics by rote—loading the brush with contrasting values, holding the brush correctly (straight or slanted, depending on the stroke), and applying the correct pressures to the brush as they pull it.

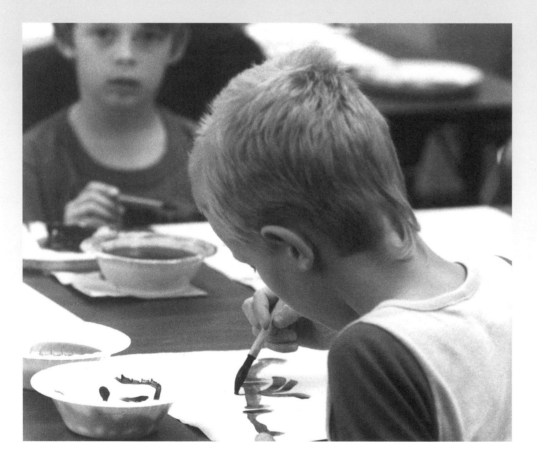

I started my demonstration by asking the young audience to guide my movements as I made a painting of the wild orchid leaves. First, I loaded my brush, held it upright in readiness, and asked them to direct my strokes. One child said, "Pull the brush on the tip." I did but waited for the next instruction. Another said, "Press then pull in a little different direction." I did as he said but stopped at the end of the stroke until a third child advised me to "pull and lift away like an airplane leaving the ground." There were some false starts and wrong directions, but the end results were good.

Much of my teaching experience is with adults. Adults and children approach sumi-e very differently. Children are more untrammeled than adults and are unafraid to make what may seem like a mistake. They are also more willing to take chances. Because of the success of this exercise, I have since used this method with adults with very successful results. Sumi-e is especially dependent on freedom of motion.

Once, during a lesson, a child in the back of the room shouted: "Look what I can do!" She was swinging her arm with a shoulder action, holding her brush straight up with multicolored layered paints. She had produced a stunning painting with beautifully blended and well-shaped strokes. Best of all, she remembered how she had made it!

OPPOSITE: **BRUSH PLAY**
*From the collection of the artist.*

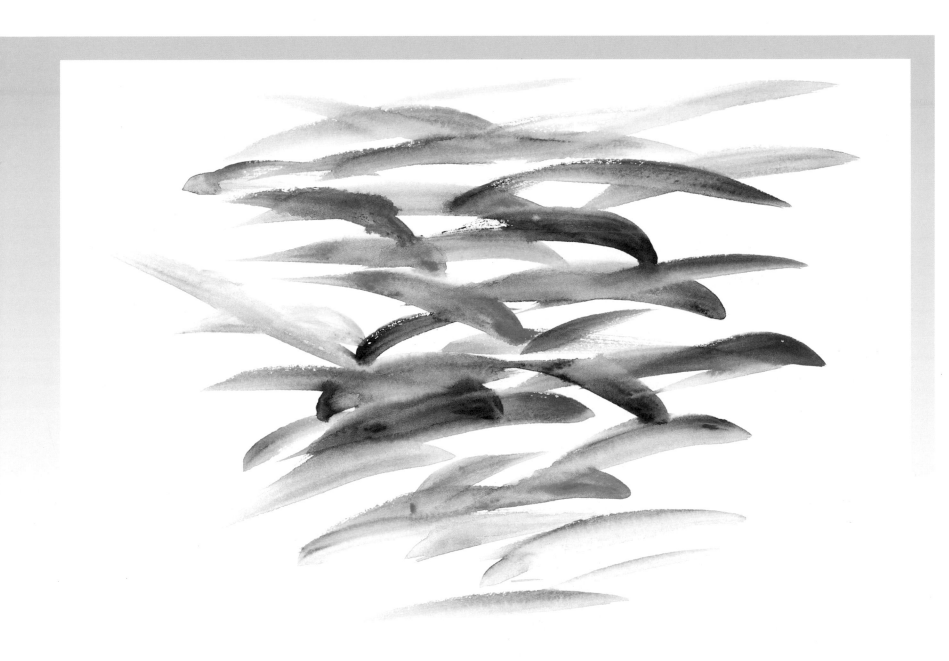

125

# Glossary

**ACCENT STROKE** A thick-thin stroke used to accent important parts of a shape.

**ALL-IN-ONE BRUSH** A brush that is suitable for all strokes.

**BUDDHISM** A dominant Eastern religion.

**CALLIGRAPHY** Beautiful writing.

**CHOP** A seal impression, most often made with cinnabar paste; it usually bears the artist's name or logo.

**DANCING THE BRUSH** Using a dancing motion to paint a lively stroke.

**DREAM JOURNEY** A landscape painting based on memories or imagination.

**EXPRESSIONISTIC SCHOOL** A style of art that shows objective expression of inner experience.

**FLYING WHITES** A dry-brush style of painting that involves splitting the brush hairs because of the direction and energy of the brush pull. *See Haboku.*

**FOUR FRIENDS, THE** *See* Four Treasures, The.

**FOUR GENTLEMEN, THE** The four essential strokes required for sumi-e, namely Bamboo, Wild Orchid, Chrysanthemum, and Plum Branch.

**FOUR TREASURES, THE** The four materials required to create sumi-e, namely brush, ink, stone, and paper.

**FUDE** (foo-day) A brush having bristles that are full and tapered to a fine point.

**FUJI** The sacred mountain of Japan; also called Mt. Fuji.

**HABOKU** (hah-bo-coo) A dry style of ink painting.

**HAIKU** A form of Japanese poetry.

**HAKE** (hah-kay) A brush whose bristles are flat and tapered to a fine edge.

**HATSUBOKU** (hah-soo-bo-coo) A wet style of ink painting.

**IDEOGRAM** A graphic representation of an idea.

**IMPRESSIONISTIC SCHOOL** A style of art that shows the artist's impressions of reality.

**INK PAINTING** *See* Sumi-e.

**KAISHO** (cai-sho) Square style of *shodo.*

**KIMONO** Japanese dress.

**LINEAR SCHOOL** Brush strokes without shading.

**LITERATI** Scholar-artist.

**MONOCHROMATIC** Using only one color; in sumi-e it usually means black and shades of gray.

**NEGATIVE SPACE** The unpainted area of a painting regarded subjectively.

**PAGODA** A multistoried tower, usually part of a temple.

**PALETTE** A surface to accommodate paint. A palette for sumi-e can be shaped like a saucer or like a cluster of shallow cups joined together, called a chrysanthemum dish.

**RICE PAPER** Paper made from fibers of the rice plant.

**SCHOOL (OF ART)** A consistent style of art.

**SENSEI** (sen-say) A teacher or mentor; title of respect.

**SHIKISHI BOARD** (she-key-she) Rice paper mounted on board.

**SHODO** (sho-doe) Japanese calligraphy.

**SHODO KA, SHO KA** One who paints *shodo* professionally.

**SOSHO** (so-sho) Grass speedstyle of *shodo.*

**SPLASH INK STYLE** *See Hatsuboku.*

**SUMI BAR** Sumi ink compressed into a hard bar.

**SUMI-E** (soo-me-ay) Japanese ink painting.

**SUMI INK** The ink traditionally used for sumi-e.

**SUMI-E KA** One who paints sumi-e professionally.

**SUMI-E STROKE LANGUAGE** *See* Four Gentlemen, The.

**SUMI-E STYLES**  Different schools of sumi-e that developed throughout the ages.

**SURIMONO**  (soo-ree-mo-no) Traditionally, a woodblock printed greeting card.

**SUZURI**  (soo-zur-ee) Ink stone.

**SWIPE FILE**  An artist's pictorial reference file.

**TARASHIKOMI**  (ta-ra-she-ko-me) A method in which drops of pigment are dripped onto a wet wash.

**TRANSCENDENTAL**  Abstract, going beyond the limits.

**TSUNAMI**  Tidal wave.

**UKIYO-E**  (you-key-oh-eh) Woodblock prints depicting the "floating world."

**WASH**  Black ink or paint, thinned with water to create shades of gray.

**YO BIRD**  Yolanda's individual style of rendering birds.

**ZEN**  A mystical Buddhist sect.

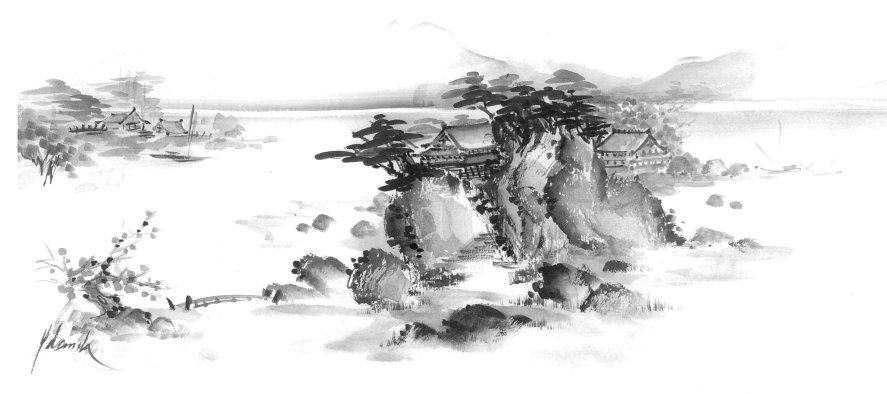

# Index